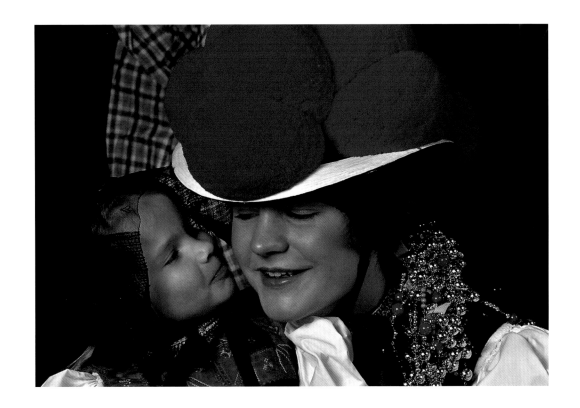

Journey through the

BLACK FOREST

Photos by
Martin Schulte-Kellinghaus
and Erich Spiegelhalter

Text by
Annette Meisen

Stürtz

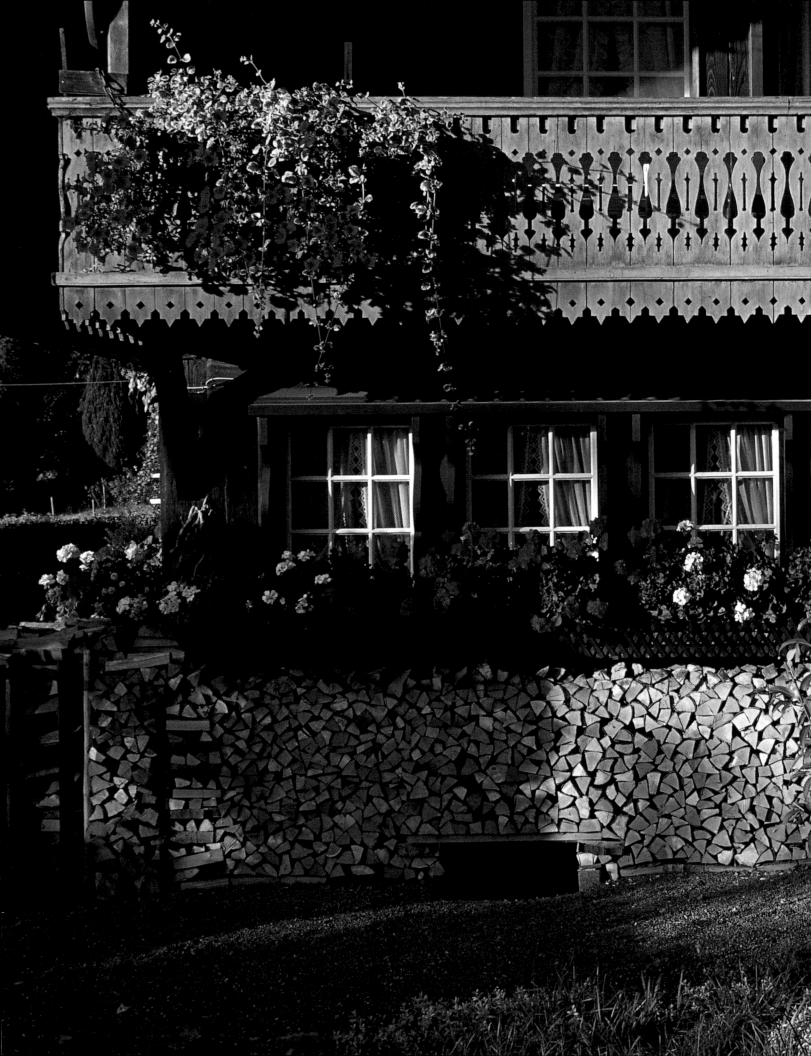

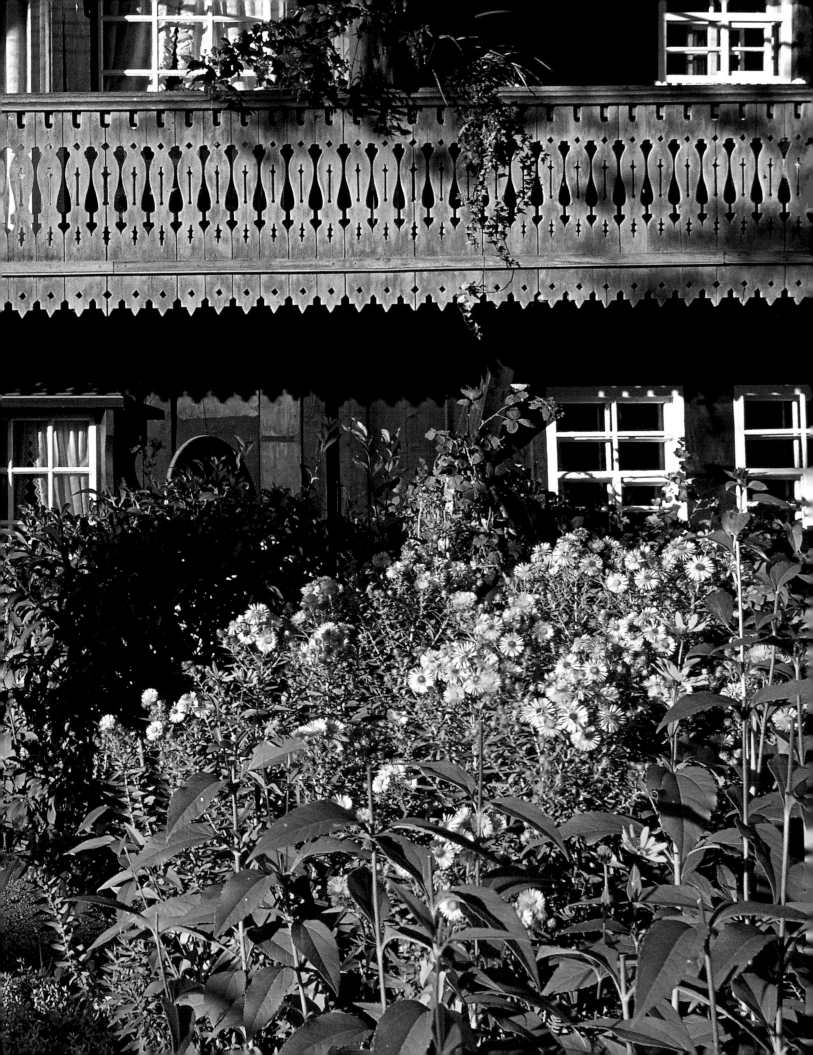

CONTENTS

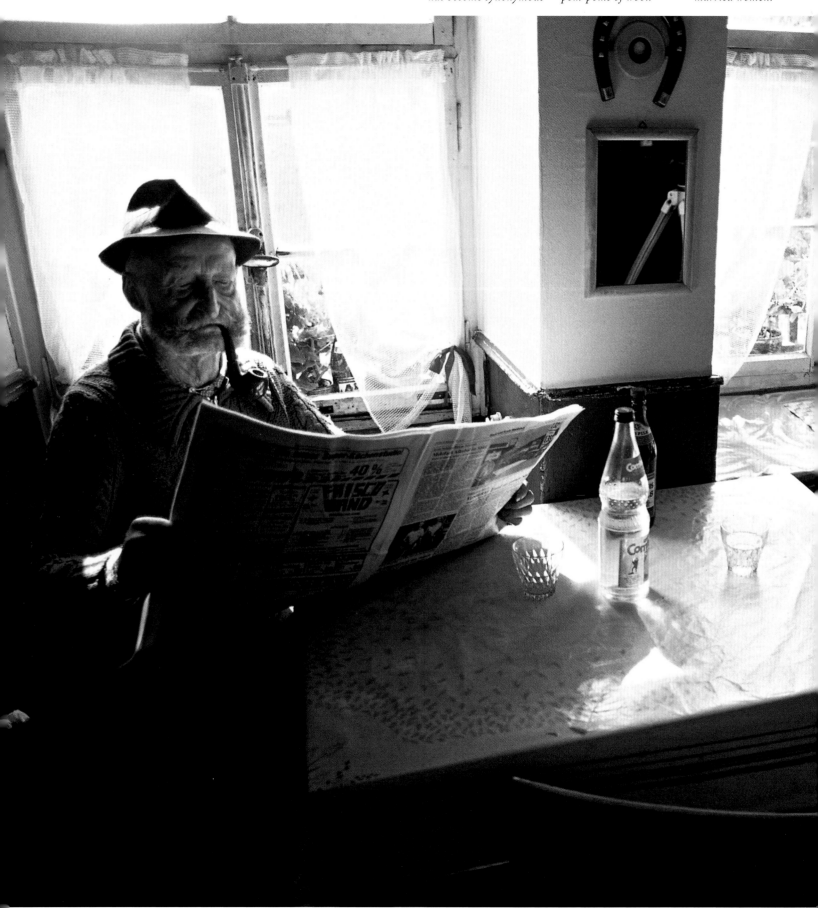

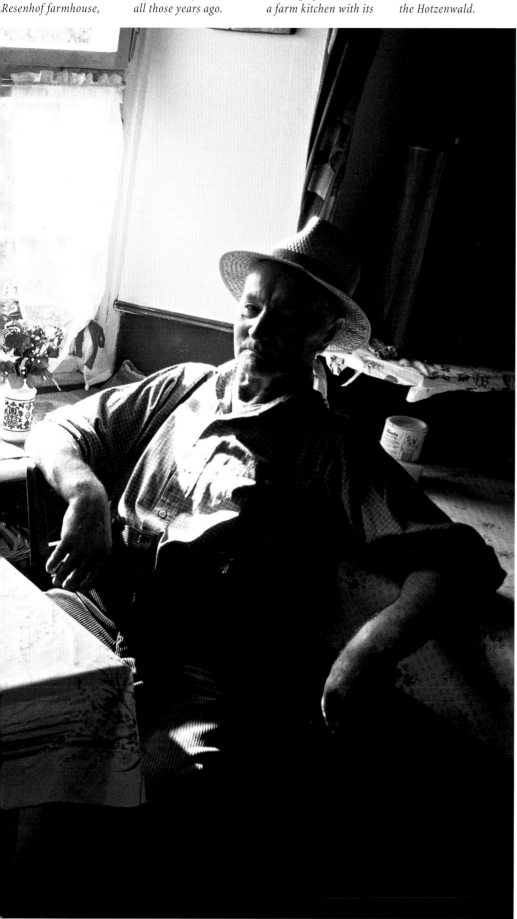

9

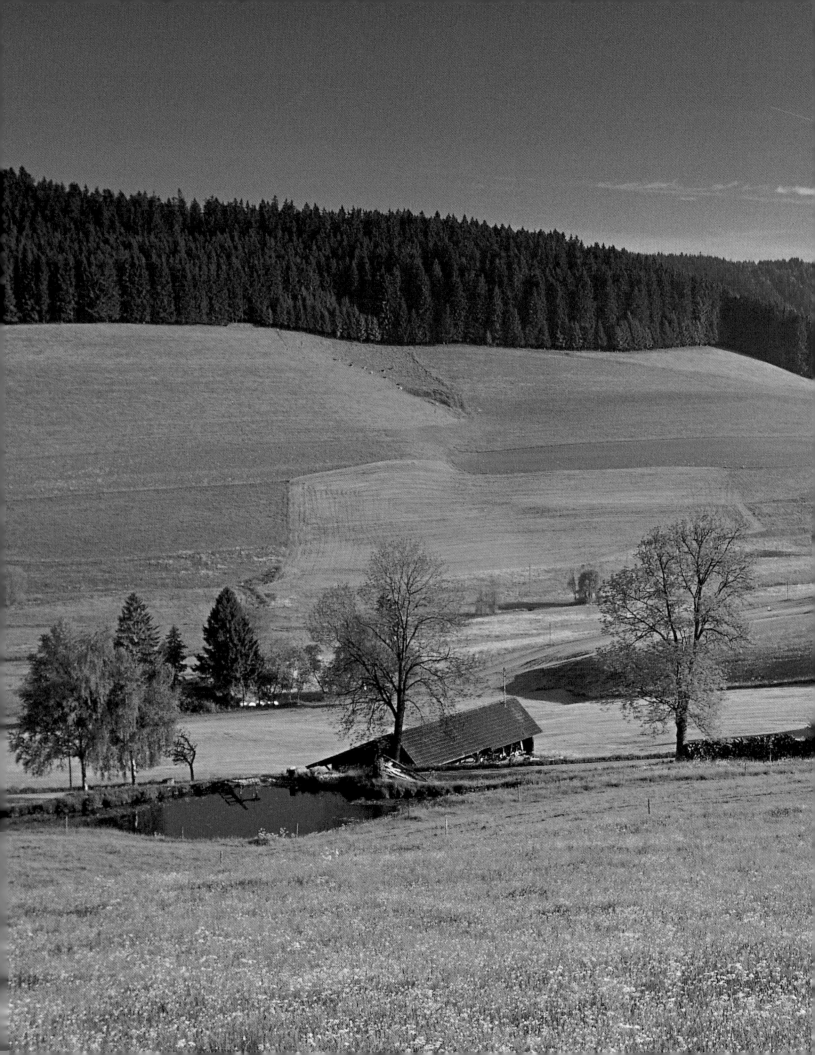

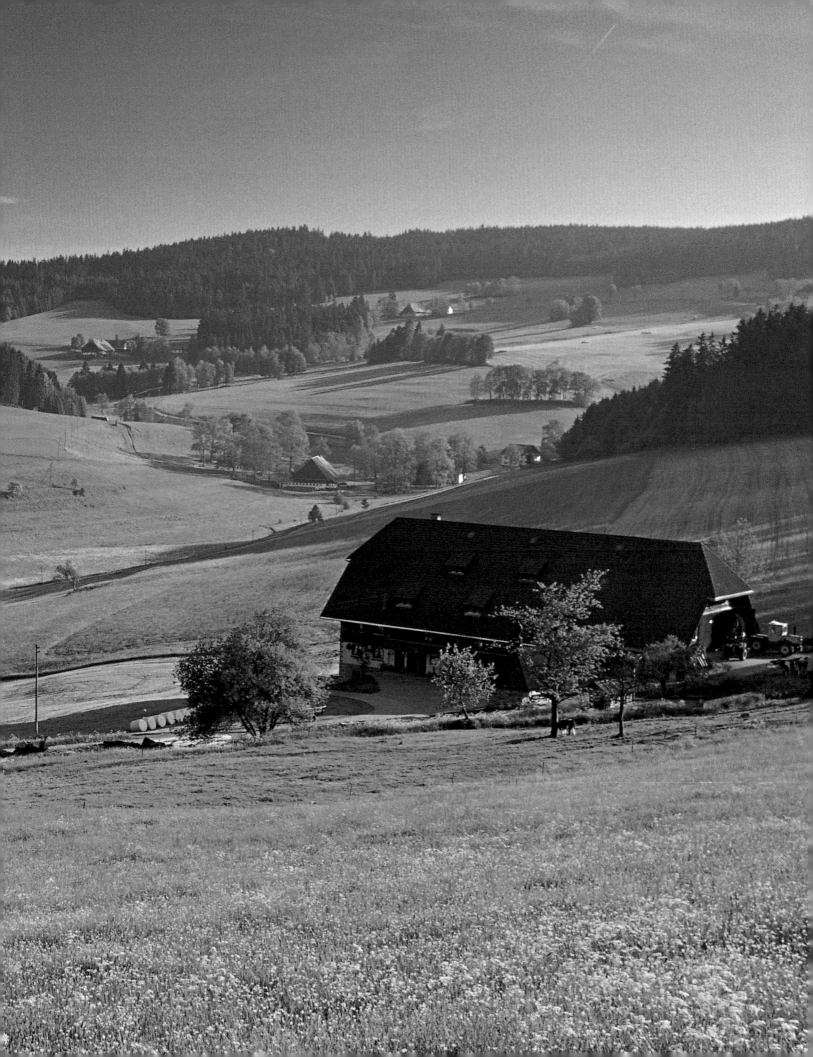

When you think of the Black Forest, what immediately springs to mind? Dark pine forest, wooden chalets and cuckoo clocks, probably. And maybe Black Forest Gateau and thick slices of cured ham. Possibly even young women in local costume sporting rather ridiculous hats with enormous red pom-poms. Whatever your favourite cliché, you're not alone. Berlin composer Leon Jessel was so taken with the area that he wrote an entire operetta of clichés, his tale of the bustle of the city versus the peace and quiet of the countryside, of hard-nosed ambition softened by coquettish modesty, of the trials and tribulations of love enlightened by humour proving extremely successful. His "Schwarzwaldmädel" was filmed in 1950, bringing to the screen the story of a young musician from Berlin falling for a young country lass employed by the local village bandmaster, which after an inevitable amount of confusion and misunderstanding eventually has a happy ending in the mountains and valleys of the Black Forest. 50 years on the clichés have stuck, with the Black Forest still providing the perfect setting for a number of popular German soaps.

The nothing less than idyllic scenery of the Black Forest has provided many with inspiration over the years. Hans Thoma (1839–1924) was one, one of the most famous German painters of the late 19th century, born and bred in the picture-book village of Bernau in the Black Forest. Refusing to conform to the pioneering trends of the day – he was familiar with the work of the Impressionists – Thoma went his own way in the

IDYLL AND INSPIRATION

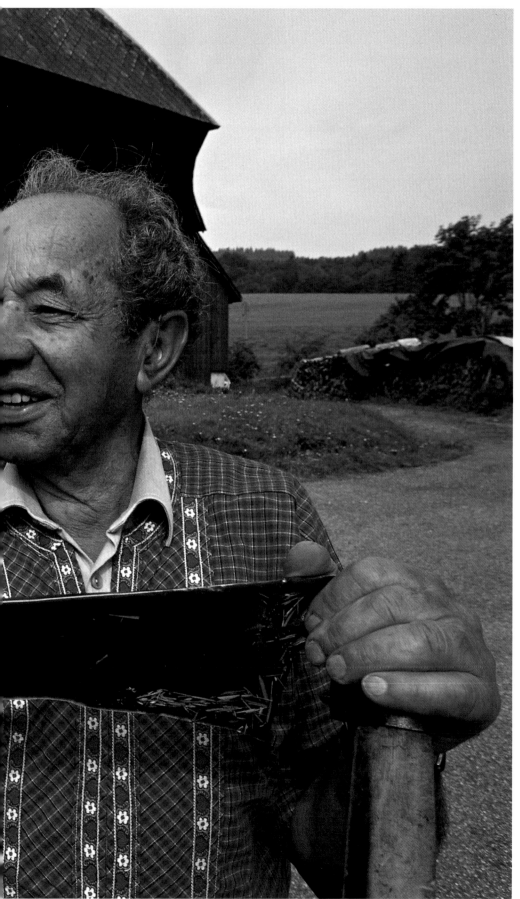

world of art. Success was long in coming, his naturalistic paintings of the places of his youth and childhood not readily appreciated by a discerning public. Forced to paint clock dials to earn a crust in his youth, in 1899 his perseverance was finally rewarded and he was made director of the art gallery and professor of landscape painting at the art academy in Karlsruhe. He died famous in 1924, his work forever the subject of controversy.

Another famous Black Forester was also obliged to turn to clockmaking to help make ends meet. Writer Hermann Hesse was born on July 2, 1877 in Calw, a town in the northeast of the Black Forest, where he spent his formative years. He was later sent to study at the seminary of what was then the monastery of Maulbronn, running away in 1892 to spend several years working as a craftsman, among other places at a workshop specialising in tower clocks in his native Calw. The regimental authoritarianism of his Pietist upbringing and the constant whirring of clock mechanisms were to provide the fuel for his autobiographical novel "Unterm Rad" (Beneath the Wheel), written in 1906. Hesse received international acclaim much later in 1927 with his novel "Der Steppenwolf" (Steppenwolf).

Johann Peter Hebel (1760–1826) is another of the many creative minds to emerge from the Black Forest. His original short stories ("Kalendergeschichten") still delight readers today. Hebel's greatest love was the Southern Black Forest where he spent a happy childhood. In his "Alemannische Gedichte" (Alemannic Poems) he affectionately describes the people and places of his homeland in a local dialect "which tastes of farmhouse bread and country air", to quote Marxist philosopher Ernst Bloch. His poems had made the Alemannic tongue a presentable literary vehicle – a remarkable achievement, considering it was a vernacular which transcended national boundaries (Lichtenstein, Switzerland, the Upper Rhine Valley, the Black Forest, Swabia and Southern Alsace) and was thus both a cultural and political issue. And still is. The Württembergians in the north and east Black Forest, the Badensians in the west and the south, the West Bavarians, the Tyroleans and a good percentage of the German-speaking Swiss and South Alsatians are all Alemanni, their language spoken in a section of Europe which spreads from the River Murg about

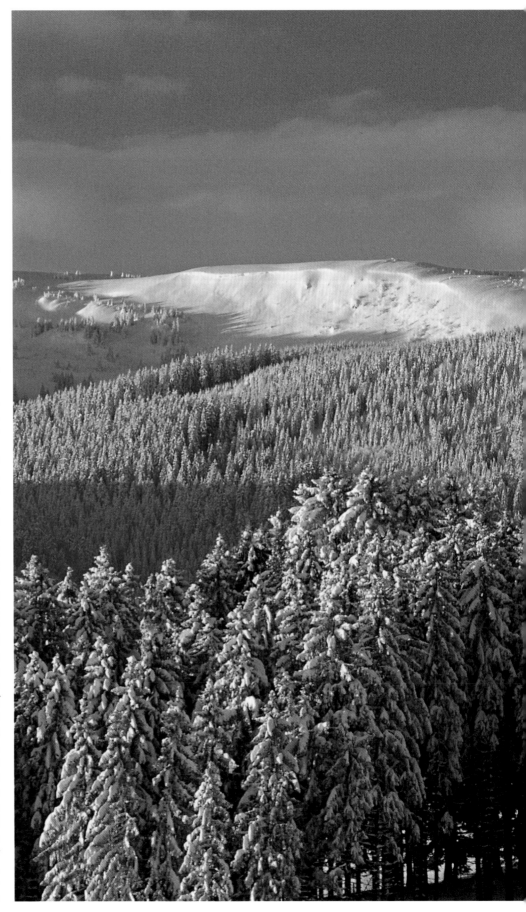

30 kilometres (20 miles) south of Karlsruhe to the Ries Basin and Heilbronn to the River Lech between Switzerland and Austria.

A TURBULENT HISTORY

The Alemanni were a Germanic people who moved south in the 3rd century AD. After driving out the Romans they settled on the edge of the Black Forest. Two hundred years later they were conquered by the Franks but allowed to keep their settlements. Under the Christian Franks missionaries came to the Black Forest. Monks from Ireland and Scotland cleared sections of forest and built monasteries in remote wooded locations. Over the centuries these became great centres of learning engaged in intellectual exchange. By the ninth century much of the Black Forest was inhabited. During the Middle Ages the region was controlled by a number of powerful dynasties. The Zähringens founded the city of Freiburg in 1120 and later Offenburg and Villingen. While the great houses grew ever more dominant and their castles and monasteries ever more numerous, the serfs lived a life of abject poverty. At the end of the 15th century malcontent Black Forest farmers joined forces with the revolutionaries of the Bundschuh, a movement symbolically named after the wooden peasants' shoe. The ensuing revolts were brutally suppressed. The Reformation brought more unrest to the area, with minions forced to take on the religious convictions of their local ruler. The Thirty Years' War, fought with incredible cruelty by imperial, Bavarian, French and even Swedish troops, brought devastation to the Black Forest, with the population only safe in the remotest corners of the forest. During the 17th century the region experienced a modest boom. A functioning system

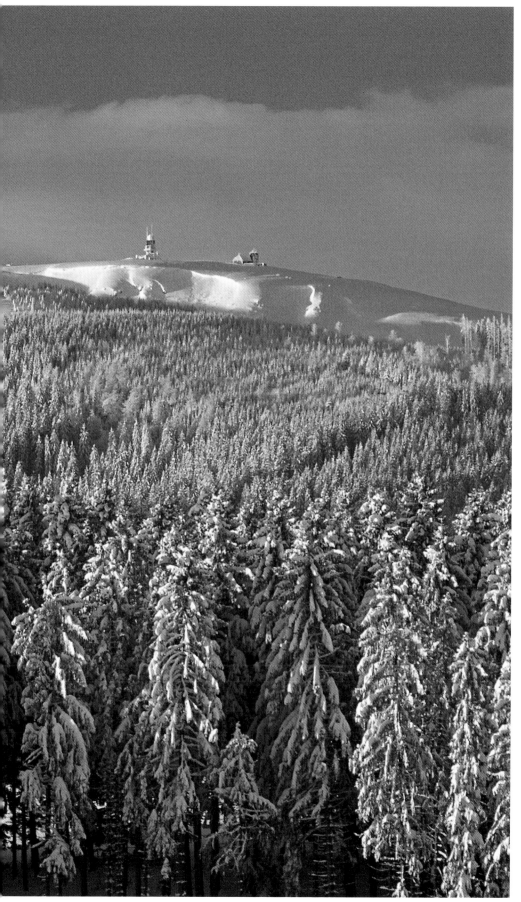

of forestry was introduced, enabling farmers, charcoal burners, raftsmen, textiles, glass and clock manufacturers to earn a living from the raw materials the area supplied in generous abundance. The Napoleonic reforms of 1805 and 1806 split the populace in two, creating the states of Swabia and Baden. In 1806 Baden fell under the auspices of a grand duke; in 1805 a king was instated to oversee the dominions of Württemberg. Neither measure brought prosperity to the area; in 1815 the land was racked by famine, the Baden Revolution was thwarted in 1848/1849 and in 1870/1871 the Black Forest found itself at war with France. Unity was only again achieved after the Second World War when in 1952 the local inhabitants voted for a joint state of Baden-Württemberg in a famous referendum.

FESTIVE DRESS, FOOLS AND "FASNET"

What has unified the people of the Black Forest throughout all their hardships is the festival of Mardi Gras, Germany's national silly season. The right terminology is important here; despite local variations the indigenous population is adamant that the prelude to Lent is known as "Fasnet" – and not "Fasching", "Fassenacht" or "Karneval" as elsewhere in Germany. This is when, in the run up to Ash Wednesday, fools and demons in places such as Elzach and Rottweil noisily drive out the evil spirits of a long, harsh winter.

A tremendous amount of loving care and imagination goes into the making of both "Fasnet" costumes and all other forms of traditional dress. National costume is a major feature of the region's many processions and religious festivals – and doesn't come cheap. The elaborate dresses and shawls, jackets and waistcoats are specially tailored by haute couture outfitters. There is also an incredible array of extravagant headwear: the world-famous red pom-pom hats from the Gutach Valley, the trademark of the Black Forest; the caps of the Markgräfler Land with their up-turned lappets and huge bows with long strands of silk; the tie-on caps of the women of St Märgen and St Peter which protect their ears from the cold in winter or their straw hats covered in white or black velvet. There is also the "Schappelkrone", a metal construction studded with tiny mirrors, glass flowers

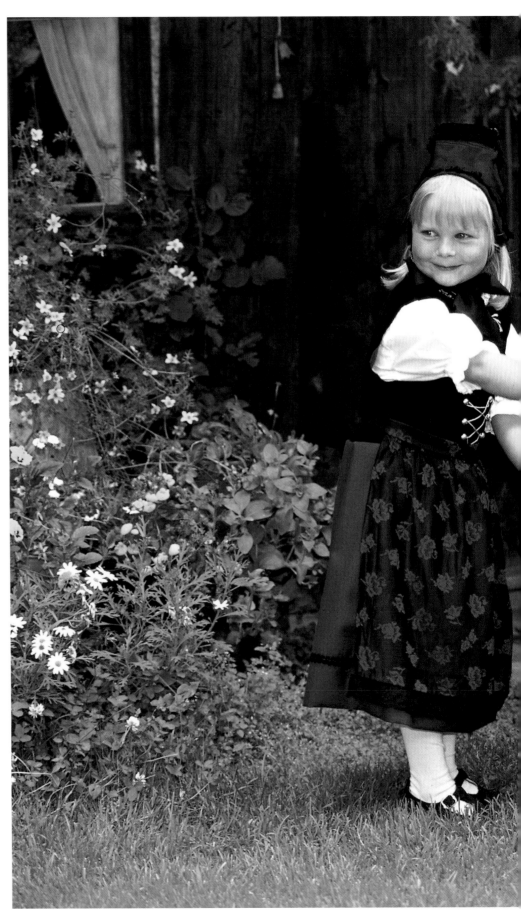

or glass pearls, said to represent the crown of the Virgin Mary and thus traditionally only worn by maidens. The cap is still the standard head covering at weddings and for girls taking their first Holy Communion all over the Central and Southern Black Forest.

WOOD CARVING AND THE CUCKOO CLOCK

The long winters have always been put to good use by the industrious inhabitants of the Black Forest. Entire families could be found beavering away at wood carvings on dark evenings, making all kinds of useful objects for the home, including wooden shingles for the enormous hipped roofs of the region's famous chalet farms. The 17th century saw the emergence of the first wooden clocks from the Black Forest, providing farmers with a welcome additional source of income and in time becoming a successful industry in its own right. Both the wooden cases and mechanisms were originally carved by hand. The cuckoo clock in particular proved extremely successful and is still exported in large quantities all over the globe. The Black Forest time machine, with its traditional gatekeeper's cottage front, is, however, a popular target for cheap imitation; only those who purchase a genuine Black Forest product take home a piece of local history. The first clock with a cuckoo striking the hours was invented by Franz Ketterer in Schönwald north of Furtwangen in 1740. The Deutsche Uhrenstraße (German clock route) honouring his creation winds through the magnificent scenery of the Black Forest and the Baar, passing a number of museums, clock factories, clockmaker's workshops and artist's studios along the way.

Another theme route, the Glasträgerweg or glass merchants' route, can be walked in a good eight days from Todtnau-Aftersteg via

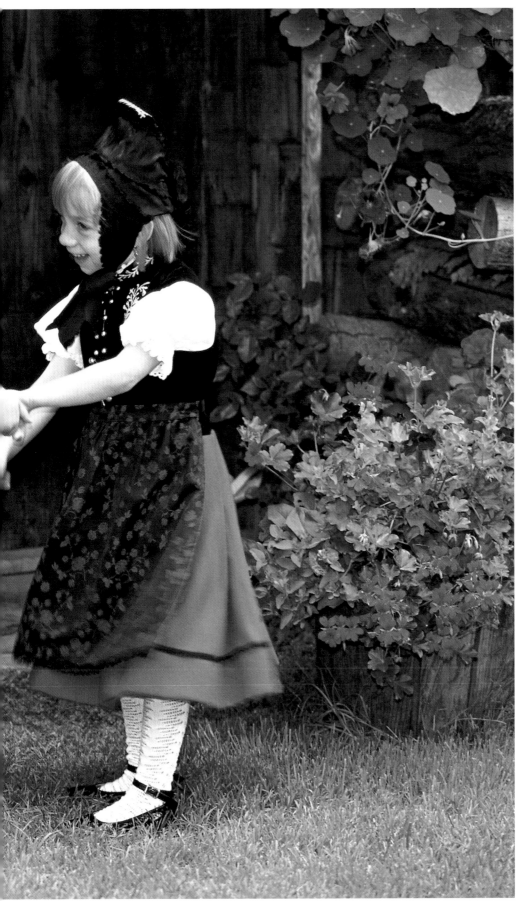

Feldberg Mountain, the Schluchsee, St Blasien, Bernau and the Hotzenwald to Laufenburg on the High Rhine. The Schluchsee area was where the glass industry had its beginnings at the end of the 16th century. The forest was very different then; beech trees, which provided an ideal source of potash, and granite rich in quartz were the ingredients needed to make glass. Readily available, these were felled and quarried in great quantities. After 300 years of glassmaking the landscape was full of gaping holes where man had exploited the resources of nature. Incredibly, the area quickly recovered, with fast-growing spruce trees soon establishing and giving the forest the typical dense green hue it still has today.

WORKING THE WATERS

Yet another set of hiking trails explores an ancient Black Forest industry which has thankfully proved far less intrusive to the landscape. The country walks past farms and mills in Königsfeld near St Georgen and the three mills at the Vogtsbauernhof Open-Air Museum in Gutach are reminders of how important the milling industry once was to the region. With an abundance of natural streams and rivers, between the 18th and 19th centuries almost 1,400 mills worked the waters of the Black Forest. On remote farms and holdings people often had to rely on their own resources, making their own flour for the kitchen and grain to feed their livestock. Today around 300 mills are still in operation, many in spectacular settings which would make any miller want to cast off his apron and wander through the valleys in true Schubertian fashion.

In fact, the sheer beauty of this magnificent part of the country is enough to make anyone get out their hiking boots and head for the hills. For the more experienced there are no less than three highland trails which zigzag through the Black Forest from north to south, from Triberg to Basle, from Freudenstadt to Waldshut and from Schwenningen to Schaffhausen. And that's not all. The Schwarzwaldverein (Black Forest Walking Club) maintains over 20,000 kilometres (12,000 miles) of walks; end to end, that's about half way around the world. Cyclists are also well catered for in the Black Forest. There are now about 2,000 kilometres (1,200 miles) of signposted cycle tracks for mountain bikes, 1,400 kilometres (900 miles) of which

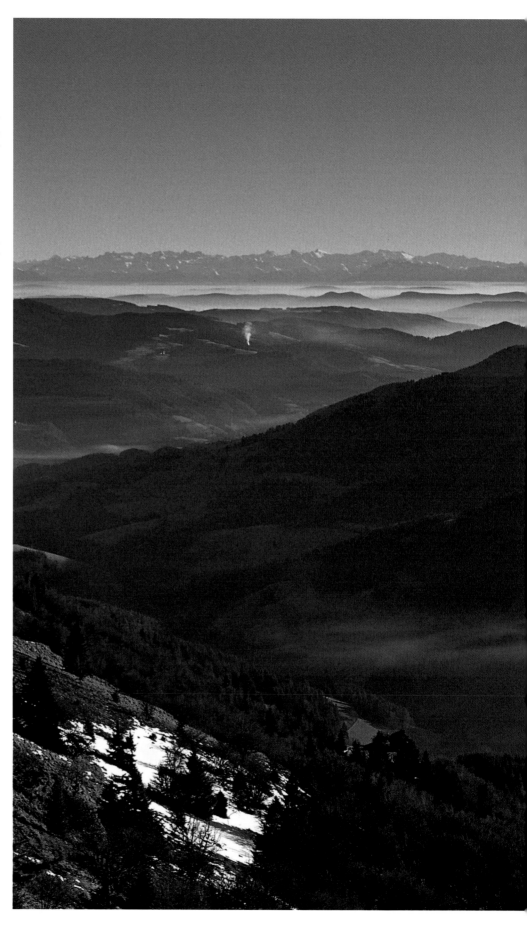

are in the Southern Black Forest National Park. And soon mountain bikers can look forward to even more; the region ambitiously plans to extend the network to a staggering 3,500 kilometres (2,000 miles), creating the longest signposted cycle track in the world.

The slopes and inclines of the Black Forest are also ideal terrain for winter sports enthusiasts. Particularly in the Feldberg area skiers and snowboarders can try out their expertise on a number of pistes which are both scenic and challenging. Skiing has tradition here; the oldest skiing club in Germany still in existence was founded in 1895 at the Feldberger Hof on Feldberg Mountain. Cross-country skiers are also in their element in the Black Forest; the longest trail covers over 100 kilometres (60 miles) from Schonach to Belchen Mountain. In the Northern Black Forest many of the cross-country ski runs take in the highlands and are blessed with plenty of sunshine and spectacular views out over valleys shrouded in mist. More recently the area has been the venue for dog sleigh races, especially in Todtmoos.

FLOODED BY THE SEA AND FORMED BY GLACIERS

The various regions of the Black Forest – including the Vosges on the opposite banks of the Rhine – were once one. In prehistoric times an ancient sea deposited Bunter, Muschelkalk, Keuper and Jurassic sediment onto a rocky foundation of gneiss and granite. Tectonic forces then caused the land to buckle and the waters to recede; 50 million years ago a deep rift split the land in two, forming what is now the Upper Rhine. The Black Forest was pushed skywards, with higher elevations evolving in the south which still boasts the highest mountains in the

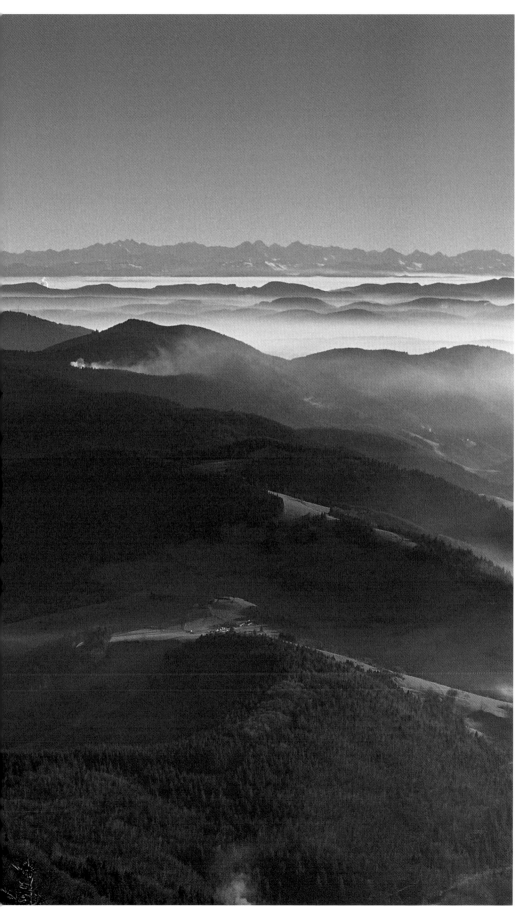

Feldberg (1,493 metres/4,898 feet), Herzogen-horn (1,415 metres/4,643 feet) and Belchen (1,414 metres/4,639 feet). Weathering and erosion have since removed the topmost layer of rock in the Southern Black Forest; in the north a protective covering of red sand-stone has remained. During the ensuing Ice Age, which came to an end ca. 10,000 years ago, great swathes of the forest were buried under thick ice. When the glaciers melted they moved, forming deep hollows or lake basins. The walls of scree or glacial moraine which shifted with them were deposited at the ends of these hollows, creating natural dams behind which water gradually collected. The Titisee in the Southern Black Forest is a typical glacial lake basin and at two kilometres (just over a mile) in length and 750 metres (2,460 feet) wide the largest natural lake in the Black Forest. Another topographical feature fashioned by the Feldberg Glacier is the Höllental or "valley of hell", named after the perilous journey which had to be undertaken to pass through this precipitous gorge carved deep into the rock face. Up until 200 years ago the only access was provided by a narrow mule track. The typical high moorland of the Black Forest – where the rare sundew thrives – is also the result of Ice Age activity. The Northern Black Forest has the largest of the region's moors and also a nature con-servation area near the lakes of Wildsee and Hohlohsee near Kaltenbronn, south of Baden-Baden. The north is also home to the most famous of the lake basins, nestling at the foot of Hornisgrinde Mountain like something out of a fairytale: the Mummelsee, named after legendary "Mummeln" water nymphs. In recent years the preservation of this unique landscape hasn't just been the primary concern of nature conservationists but also of the tourist industry who in this typical Black Forest setting see a potential source of future capital.

NEW WAYS THROUGH THE WOODS

The people of the Black Forest are finding new ways through the woods when it comes to forestry. Hurricane Lothar has provided them with an enormous open-air laboratory in which to conduct their experiments. The species and distribution of new trees can be characteristic for a particular area, helping foresters to make important decisions when managing the land. This in itself is, however,

The tiny Gertelbach stream in the gorge of the same name is positively idyllic.

an expensive and time-consuming business; to cut costs, fallen trees are no longer being cleared. In the wake of the terrible hurricanes which have decimated large areas of the Black Forest in the past few years the woods are in chaos – at least in the eyes of the uninitiated. Yet the idea of letting nature do her own repair work, as it were, has borne fruit. Strong saplings have already become established and a few years on the forest is more or less back to normal. And even if the dark green of the firs and spruce is now interspersed with the lighter, fresher hues of beech and other deciduous trees, the forest has still lost none of its romantic charm.

Despite the storms the Black Forest is as heavily wooded as it ever was – and just as popular. Approximately six million visitors flock to the area each year, making it one of Germany's favourite holiday destinations. Sport, wellness hotels, thermal spas and plenty of bracing fresh air are guaranteed to boost your spirits and revitalise lost energies. And then there's the food. Today's gourmet tourism has hit the Black Forest big time and there are no limits – neither to the delights in store nor to the cost of the bill. The number of restaurants with stars of merit, wooden spoons and chef's hats awarded by various institutions of renown is surprisingly large. There are more gourmet temples here than anywhere else in Germany. This is perhaps due to the great care and trouble taken in processing ingredients of the highest quality; coupled with great expertise, an incredibly imaginative way with food and a good pinch of joie de vivre the result is nothing less than outstanding. With the fertile plateau of the Rhine on the doorstep there is a plentiful supply of fresh fruit and vegetables. The valleys and forests are a culinary goldmine with game, wild mushrooms, berries and trout and the vines of the southwest slopes make excellent vintages. If that wasn't enough, regional cooks have taken not only the best from local Badensian and Swabian kitchens but also borrowed from their neighbours in Switzerland, the French Alsace and even Austria to

produce a genre of cooking which does the Alemanni proud. The quality of the food here is so good that gourmets and gourmands even hop over the Rhine from France for a slap-up evening meal. And that's not all. Simpler tastes are of course also catered for; what better to round off a brisk walk through the forest than a typical Black Forest platter of crusty farmhouse bread, homemade black pudding and liver sausage, cured bacon and Black Forest ham? Washed down with a glass of local schnapps (made from either cherries, plums, pears or – yes – raspberries), this is a heavenly and definitely affordable pleasure no visitor should miss.

For those who prefer to try out new creations at home, the celebrated farmers' market in Freiburg outside the minster is an absolute must. For centuries the south side of the market has traditionally sold non-food items: wooden spoons, pottery, elaborate arrays of confectionery and the like. The north side is packed with farmers selling local produce, ranging from crisp lettuce, chives and dill to radishes to onions to all kinds of cabbage, according to the season. During the asparagus harvest the stalls are laden with quality goods from the fields of Opfingen, Munzingen and Tiengen. In early summer there are sweet ripe cherries for eating and preserving. Fresh apples are sold from the orchards of Laufen, Britzingen, Ehrenstetten and the western Kaiserstuhl area; Gutedel grapes come from Ebringen. On Fridays the fishmonger has fresh trout, char and pike-perch. Late summer is the time to buy delicious cep or porcini mushrooms and chanterelles. This is also when the heady scent of new wine wafts through the air, accompanied by the spicy aroma of traditional onion flan.

Page 24/25:
The bright lights of Titisee health resort. The town is built on moraine from the Feldberg Glacier which at the end of the Ice Age formed a dam here, enabling meltwater to collect in what is now the lake of Titisee.

Page 22/23:
No less than seven valleys culminate in the Präg Basin near Todtnau, formed by glacial movement during the Ice Age.

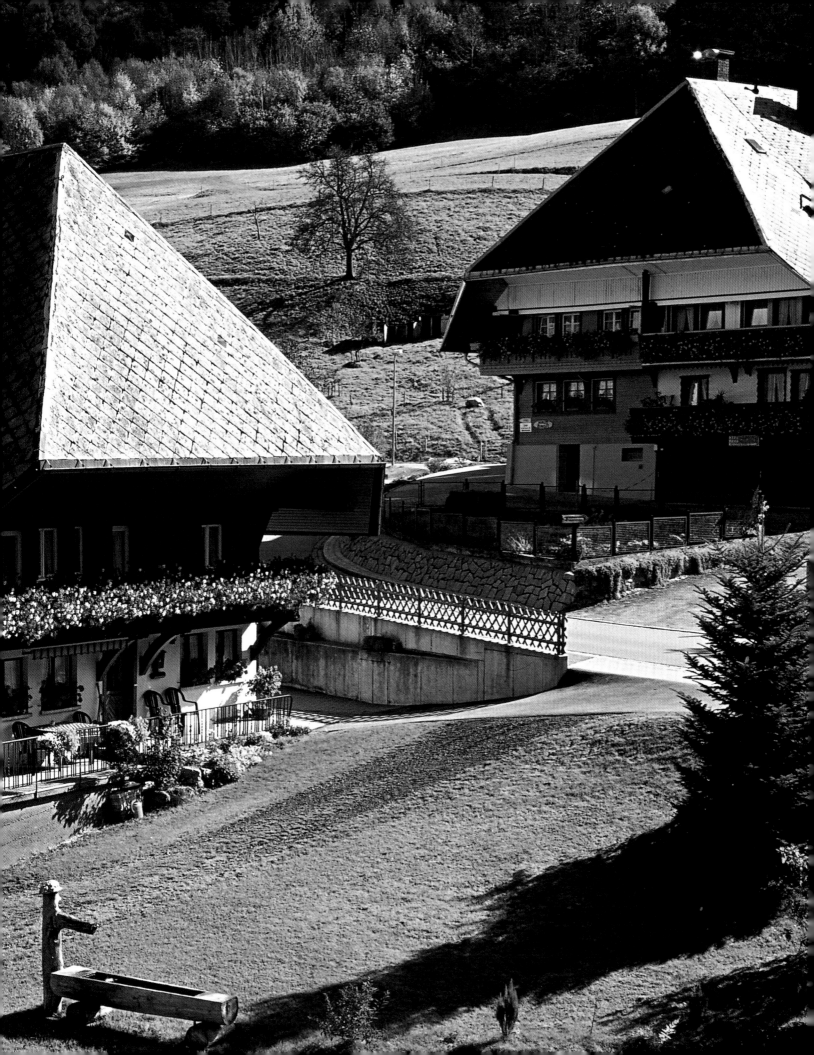

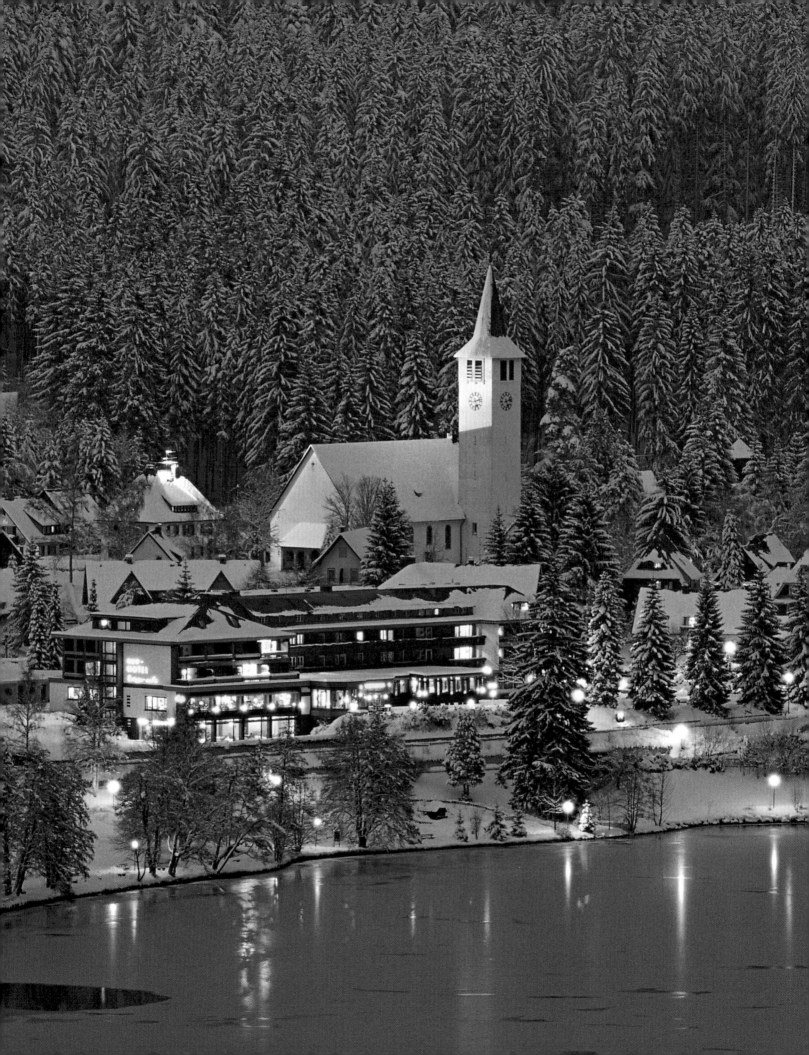

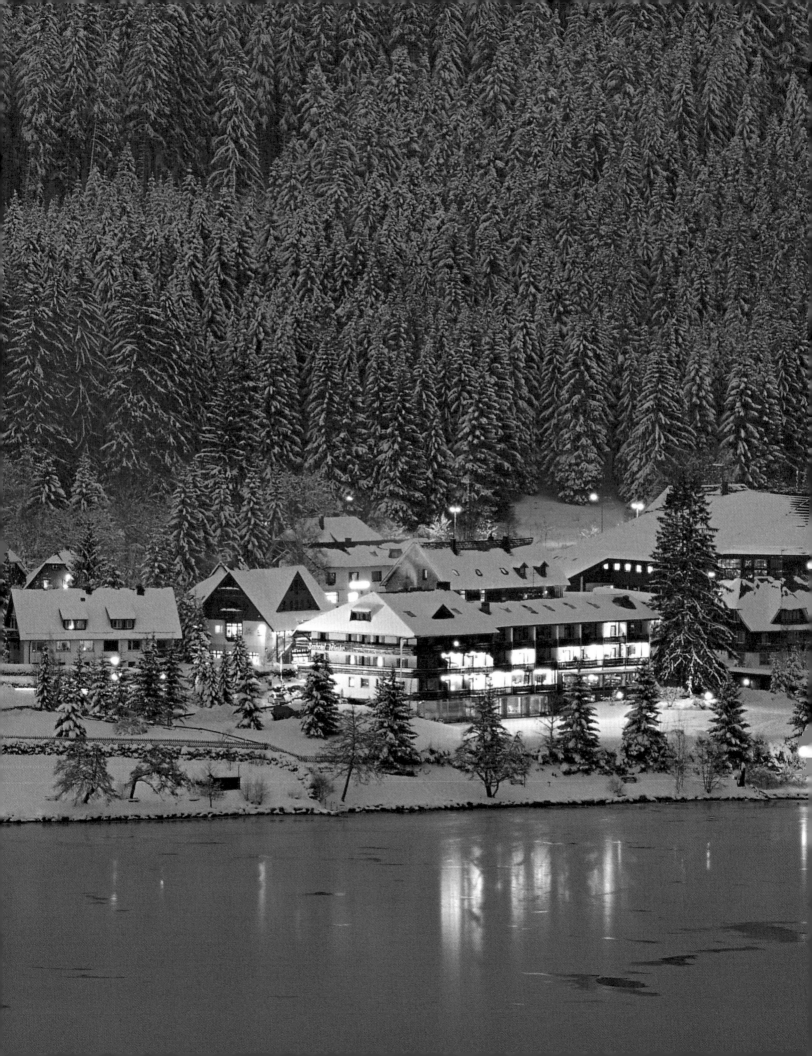

THE SOUTHERN BLACK FOREST

Wiesental or "meadow valley" certainly lives up to its name with its glorious carpet of wild summer flowers.

"Wiesen" also refers to the two rivers which wind through the Southern Black Forest to the River Rhine.

At 1,493 metres (4,898 feet), Feldberg Mountain positively dominates the highlands of the Black Forest. On a clear day there are fantastic views of the jagged peaks of the Alps from the top: from the Zugspitze to the Säntis and Jungfrau to Mont Blanc. Belchen, Blauen, Herzogenhorn and Hasenhorn are other popular summits. The surrounding scenery is nothing less than spectacular, with the sparkling lakes of the Titisee, Feldsee and Schluchsee, the Höllental Gorge, the valleys of the Wiesental and Albtal and the unique Wutachtal. To the southeast lies the Hotzenwald, its primeval forest and precipitous ravines like something out of "Sleeping Beauty".

The Kaiserstuhl is completely different, a remnant of prehistoric volcanic activity. Even Germans who've never been there are familiar with it from their national weather map; this is the tiny corner on the bottom left with the most hours of sunshine in the country, sticking up from the Rhine plateau. To the southeast is Freiburg, gateway to the Southern Black Forest and cultural heart of the Breisgau. In the Central Black Forest, northeast of Freiburg, the tops of the hills are covered in fairytale fir and pine forest, the land sliced in two by deep canyons and dotted with lonely farmsteads. Local trade and industry centres on the larger towns of Waldkirch, St Georgen, Furtwangen and Schramberg. To protect this unique part of the country, in 1999 the Southern Black Forest National Park was founded.

The cold months of the year turn the Southern Black Forest into a winter wonderland, where thatched chalets lie amidst fields of snow, glittering icicles line the banks of mountain streams and tall evergreens are shrouded in a magical blanket of hoarfrost. For both downhill and cross-country skiers, when the temperature drops and the snow starts to fall the Southern Black Forest is nothing short of paradise.

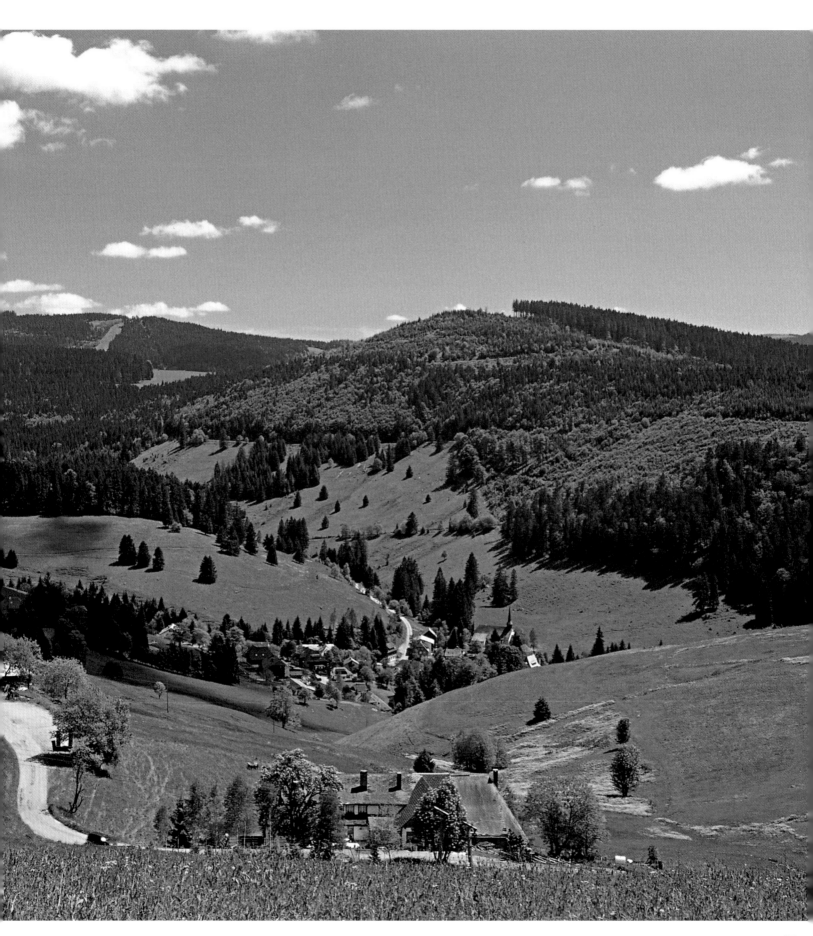

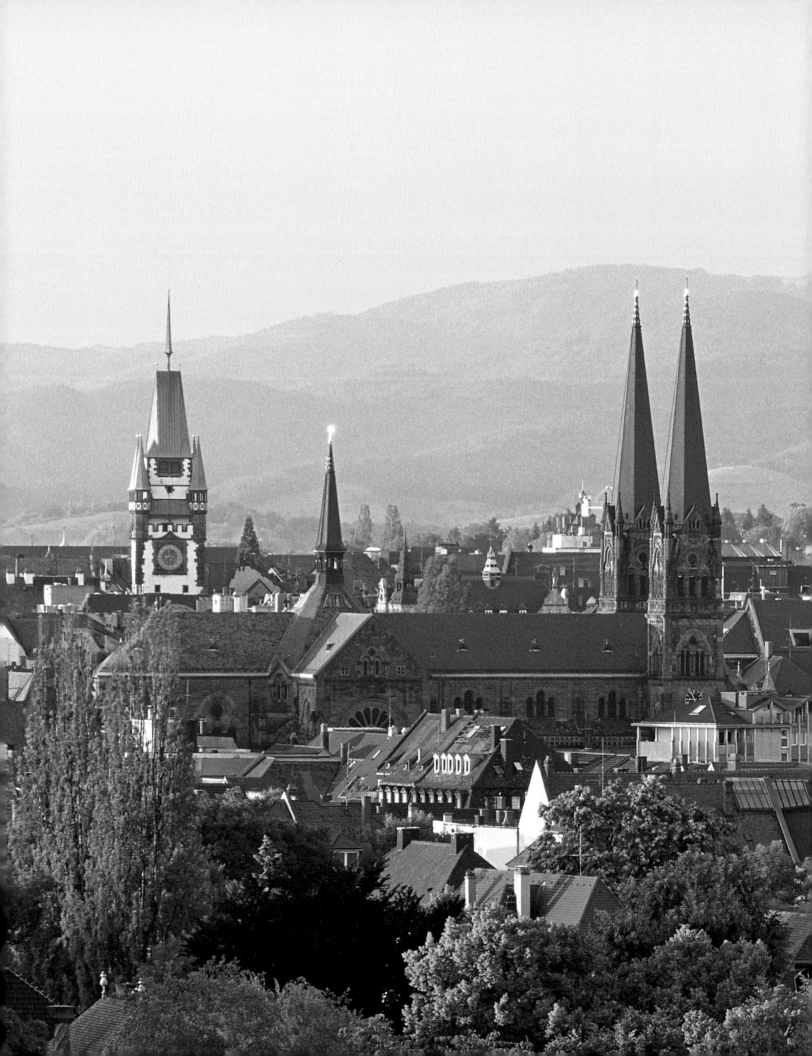

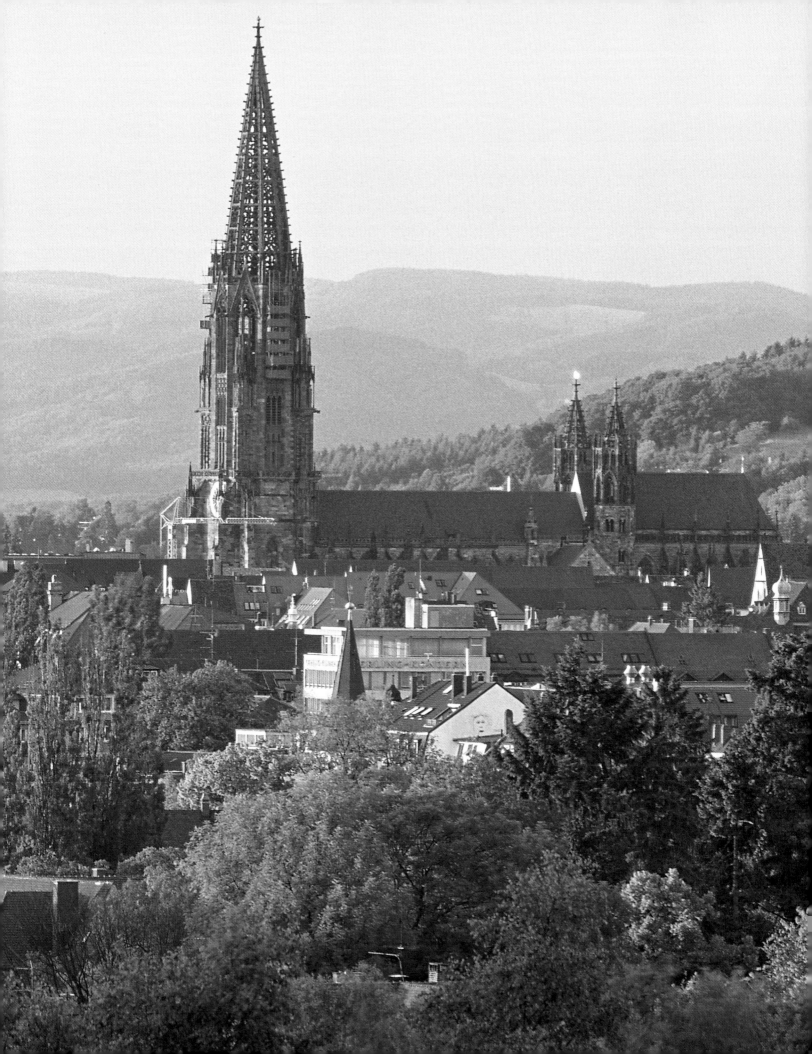

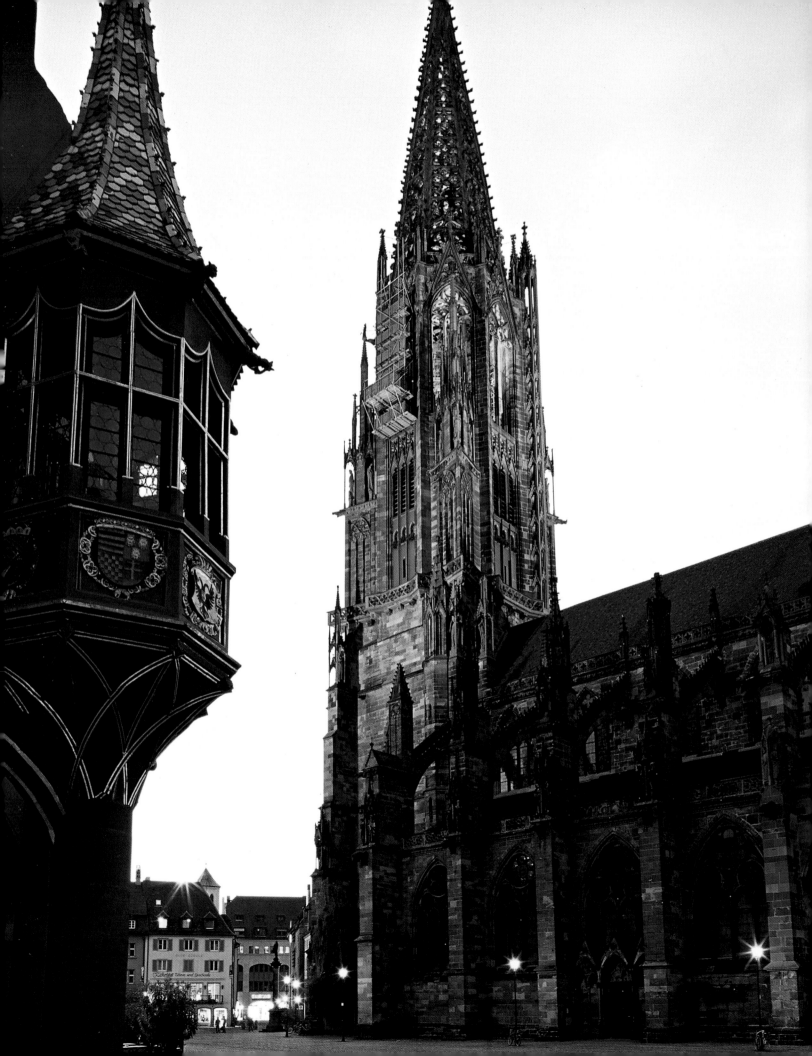

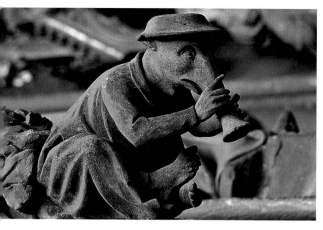
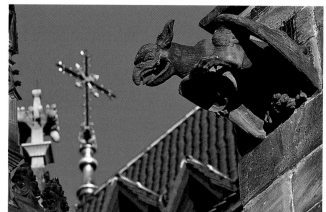

Page 28/29:
Freiburg, the metropolis of the Black Forest. Tucked into the pocket of land between Germany, Switzerland and French Alsace, the university town and seat of local government is truly cosmopolitan.

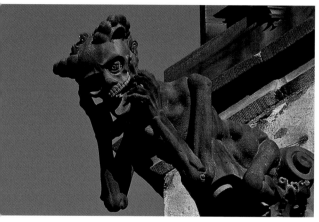

Small photos:
The gargoyles of Freiburg Minster. Looking up towards the heavens, you may be surprised to see a number of very unspiritual beings squatting on the roofs and pinnacles. The demonic "Blecker" on the far left is particularly gruesome.

Left:
The knightly figures and coats of arms adorning the facade of Freiburg's historic Kaufhaus or merchant's hall were an expression of political unity with Austria and its ruling dynasty of Habsburg emperors.

Left page:
From the Gothic to the Renaissance: from the south flank of Freiburg Minster to the ornate oriel of the historic 16th-century merchant's hall, used as a toll booth, tax office and department store.

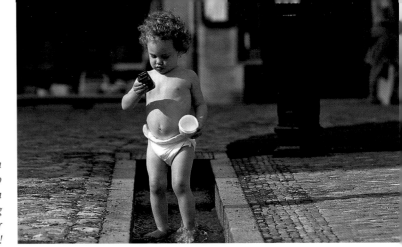

There are two things in Freiburg no local would want to do without: the farmers' market outside the minster (below) and the tiny streams which criss-cross through the town. Strangers to Freiburg have to watch where they're walking or they might get their feet wet!

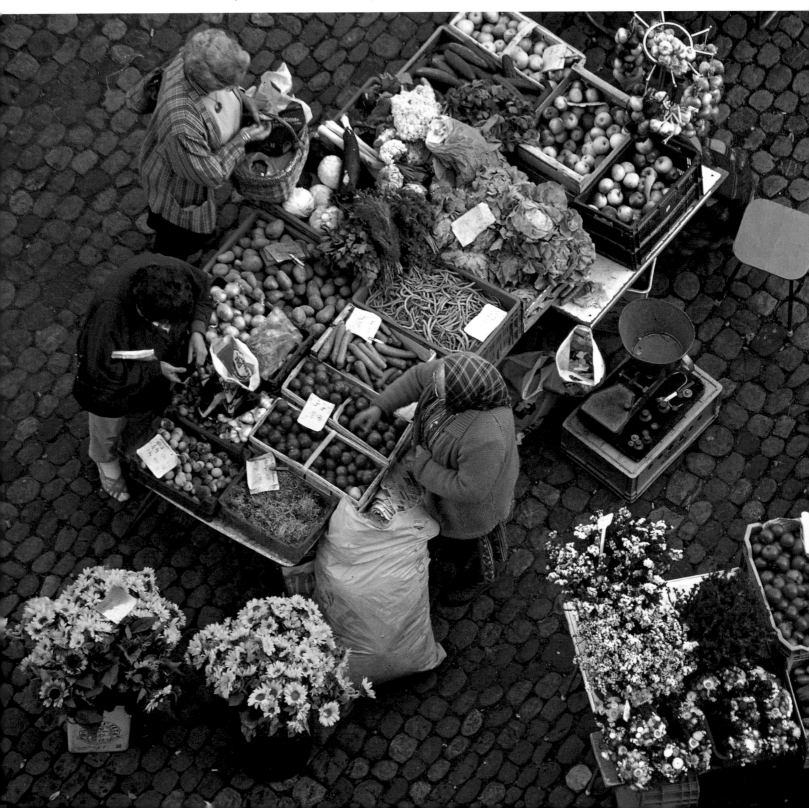

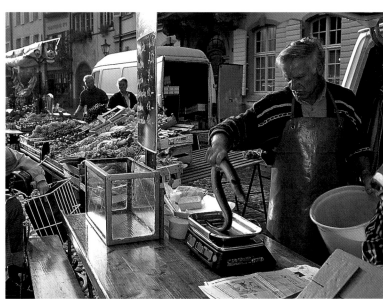

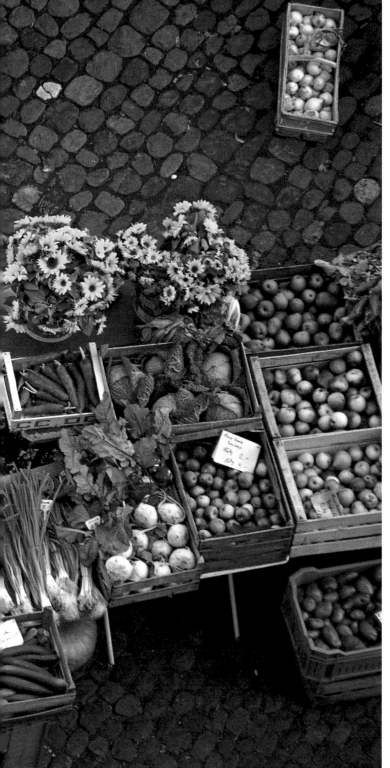

Peeling off your muddy hiking boots after a long trek across the peaks of the Black Forest, your rucksack dumped unceremoniously on the wooden bench of a country pub next to your simple platter of bread and ham, you may be surprised to learn that the Black Forest is an absolute paradise for gourmets, lauded in the highest culinary circles. This is the land of celebrity chefs and discerning connoisseurs – but also of good home cooking, imaginative, uncomplicated and always prepared to the highest quality from fresh local produce. With a slight Swabian influence in the north and a hint of the Swiss and Alsatian in the south, dishes such as the traditional farmer's platter, onion flan, roast game and Black Forest trout promise a veritable feast.

Left:
From the smokehouse to the table: curing ham near Schauinsland.

Below:
A typical farmer's platter, such as this one served in Titisee-Neustadt, consists of various products of pork and was traditionally eaten in the late afternoon.

Small photos right, from top till bottom:
In some cultures it may be considered rude to eat straight from your knife; in the Black Forest this is a perfectly acceptable way to savour fresh bacon.

Specialities of the Black Forest: "Schäufele" (salted, boiled shoulder of pork), "Schupfnudeln" (thick noodles) and sauerkraut

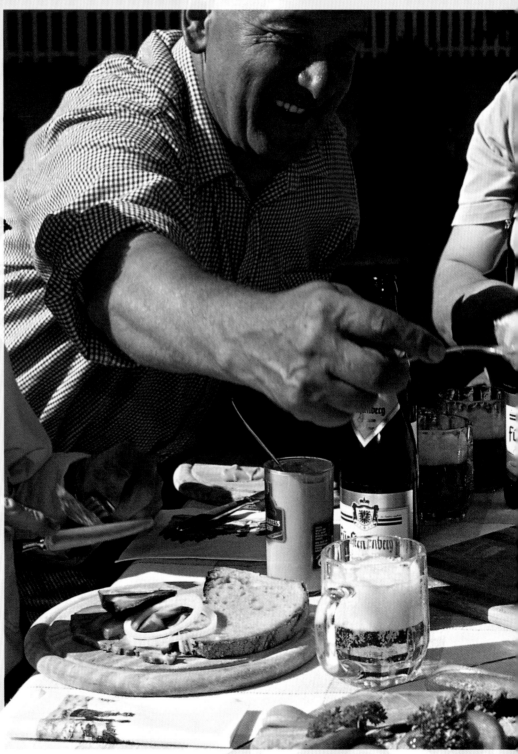

For afternoon coffee there's the famous Black Forest gateau, devilishly tempting, highly calorific and extremely elaborate in its preparation. Cabaret artist and bon vivant Gerhard Polt praises it with a religious fervour: "...Catholicism is like Black Forest gateau: luxurious and spectacular. Protestantism on the other hand is like crispbread: an ascetic rejection of everything that is dramatic." Creating the perfect, genuine Black Forest gateau is not, however, a question of faith but of the careful adherence to a not uncomplicated recipe which requires three chocolate sponge bases, heaps of whipped cream, lots of cherry pie filling, a sprinkling of grated chocolate, candied cherries for decoration and plenty of kirsch to soak the cake bases – distilled from local black cherries, of course.

GATEAU, KIRSCH, HAM AND TROUT

Cheese dairies are in abundance in the Black Forest. These golden rounds are the produce of Hinterzarten.

The fruits of autumn in the Black Forest include the delicious onion flan, the ideal accompaniment to heady new wine.

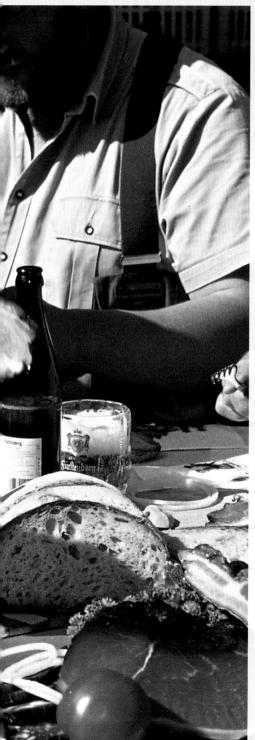

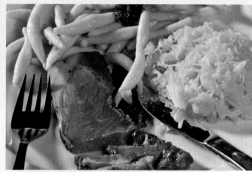

BLACK FOREST "KIRSCHWASSER" – PROTECTED BY LAW

The cherry orchards clinging to the sunny southwestern slopes of the Black Forest and the production of Black Forest "Kirschwasser" have a long tradition here. In the valley of the Rench, where the kirsch is said to be of a particularly high quality, cherries were harvested as long ago as in the 13th century and distilled very soon afterwards. The alcohol produced was originally used for medicinal purposes only; it wasn't until c. 1500 that people in Frankfurt discovered that you could also turn it into a very passable alcoholic beverage. The sale of this new spirit provided the farmers of the Renchtal with a steady – and often solitary – source of income. During the 18th century disaster threatened; the local coopers' guild tried to obtain exclusive distilling rights. A man from Strasbourg came to the farmers' aid. Bishop Armand Gaston from Rohan, the lord of the Renchtal, prevented the coopers from gaining a monopoly in 1726 and thus secured the farmers' livelihood, proclaiming: "...[The farmers] are only able to use the cherries if they distil them and sell the resulting spirit. This is their only line of business and their primary source of income..." Even today the cherries harvested in the Black Forest enjoy special protection. The European Spirits Ordinance stipulates that kirsch may only be labelled as original Black Forest "Kirschwasser" if it's made in the Black Forest from Black Forest cherries.

HAM SEMINARS AND TROUT POACHERS

The secrets of Black Forest ham can be uncovered at a special seminar at the farm of Enzklösterle. From dry salting to cold smoking newly initiated ham experts are able to spot an imitation at a hundred paces. The spicy aroma of this local speciality being smoked over branches of fir is positively addictive, irresistible even to dieting divas. When Marlene Dietrich fancied a midnight snack, for example, she was known to turf her German chef out of bed and get him to bring her a plate of Black Forest ham sandwiches, purring: "Darling, I want something nice."

Black Forest trout is also a zealously guarded regional commodity, protected by patent and farmed in a carefully controlled environment. A registered trademark, local trout thrives in the cold, oxygen-rich waters of the forest. Ernest Hemingway was a passionate fly fisherman and loved to angle for trout. During his spell as a young journalist in post-war Germany he often travelled to the Elztal in Baden. Finding the many rules and regulations imposed by the local authorities too much of a bother, he often poached his catch, a few dollars in his pocket to appease any incensed fishery owners. Hemingway would now be delighted to discover how popular his favourite fish has become; no self-respecting menu in the area would today dare to omit the delicious Black Forest trout.

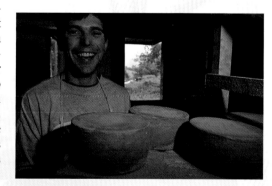

Right:
Strolling through Freiburg you will undoubtedly pass under the Schwabentor gate which has a merchant symbolising wealth and prosperity on its interior wall and St George, the city's patron saint, flanking the exterior.

Far right:
The Old University from 1726. Would-be philosophers in thoughtful poise observe the comings and goings outside the red sandstone entrance.

Right:
Heavily damaged during the Second World War, Freiburg has since been lovingly restored to its former glory.

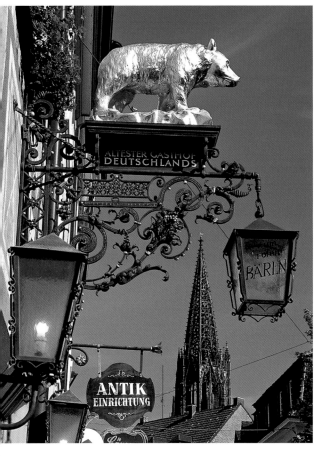

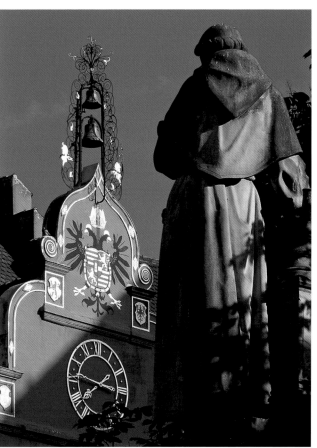

Far left:
Freiburg may be the city of art and culture but it also has a bevy of excellent pubs and restaurants for hungry art aficionados and theatre-goers. The Roter Bär is just one of them and one of the oldest inns in Germany to boot.

Left:
View of the Altes Rathaus (old town hall) in Freiburg from the parish church of St Martin's, the only surviving building of what was once a Franciscan monastery. The statue is of Franciscan monk Berthold Schwarz, who in c. 1353 is said to have invented gunpowder.

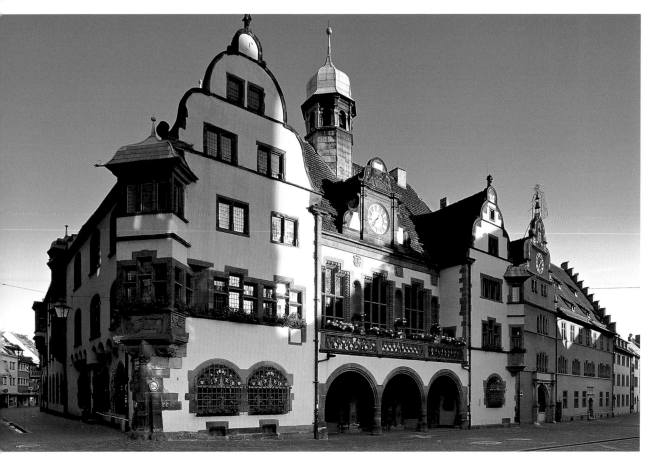

Left:
The Neues Rathaus (new town hall) was erected in its present form between 1896 and 1901. A carillon chimes at exactly three minutes past twelve each day from the tower of the central wing linking the two gabled buildings from the 16th century.

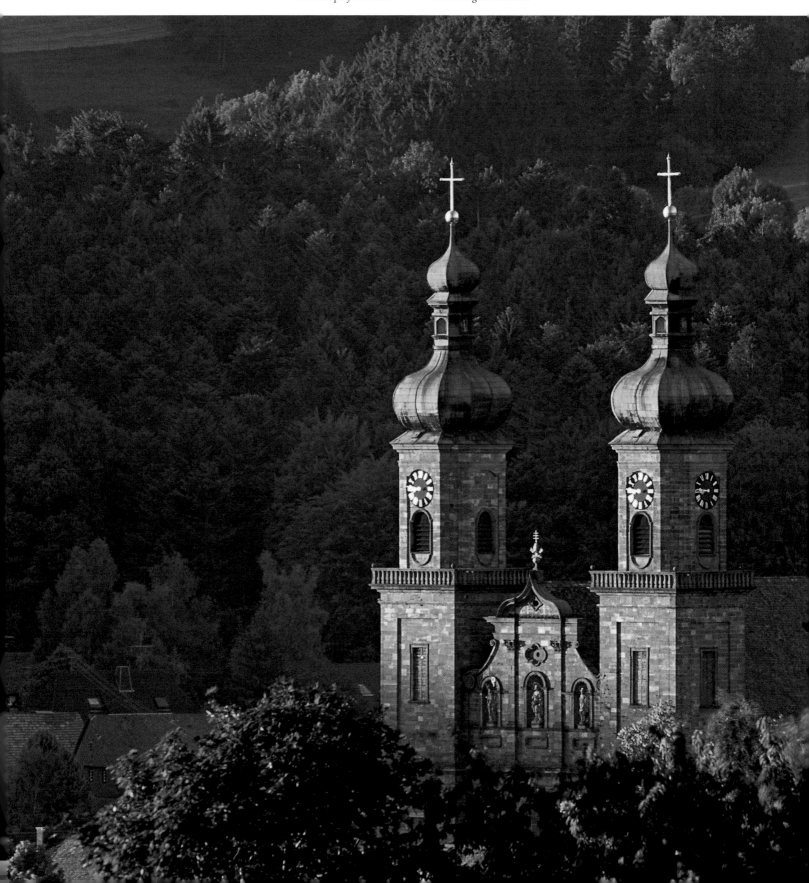

Below:
The twin spires rising up from the west front of St Peter's shine a vivid red against the lush green backdrop of Kandel Mountain. The abbey was founded by the Zähringen dynasty in 1093 and later baroqueified by architect Peter Thumb from the Vorarlberg in Austria.

Small photos right: Ancient traditions are very much alive in the Black Forest. In the former monastic village of St Peter, now a health resort, local costume is often on display, espe-cially on religious feast days. The "Schäppel" caps worn by these young girls are particularly impressive; made of metal bound in red ribbons and strings of pearls, they are said to represent the crown worn by the Virgin Mary in the Kingdom of Heaven. The white straw hats with their black velvet bands and red roses below are a much simpler affair.

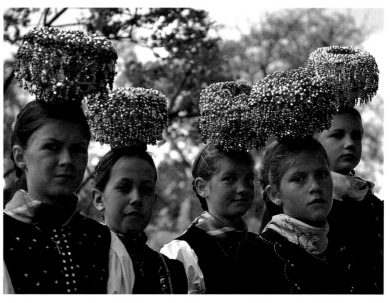

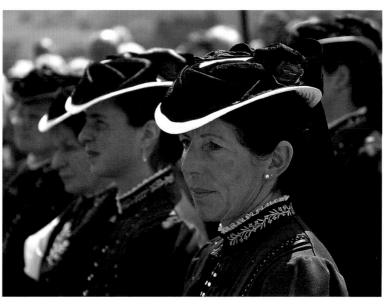

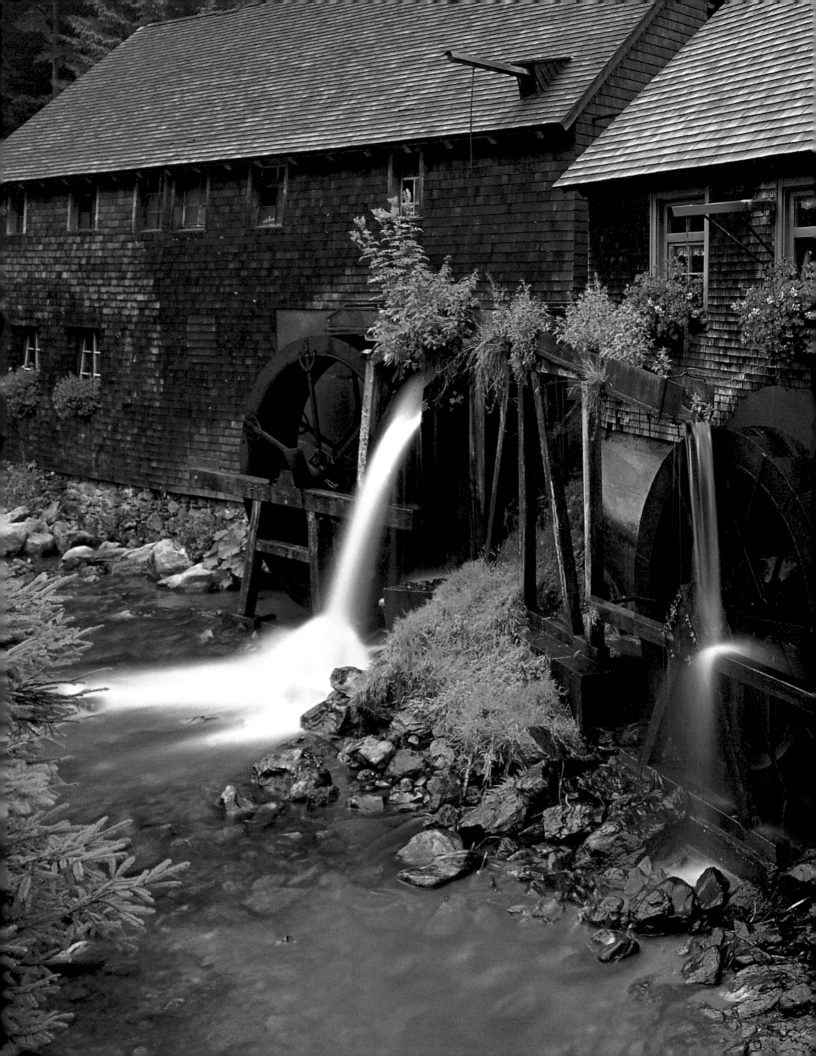

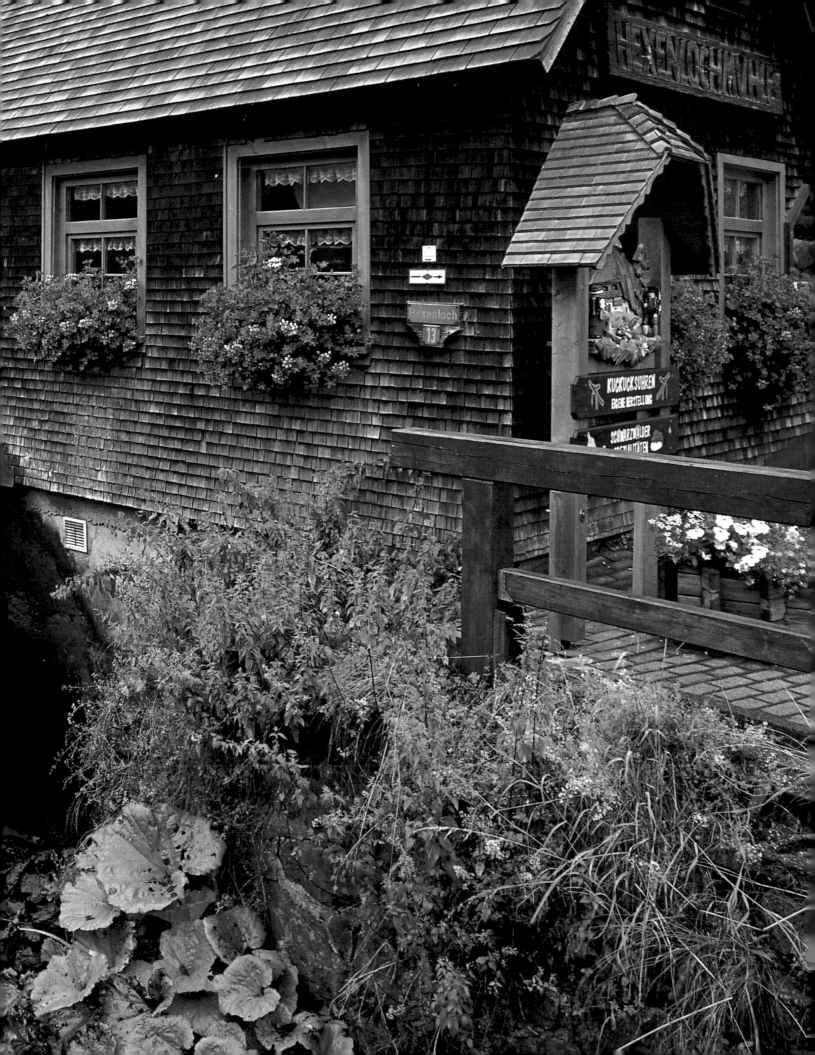

Page 40/41:
This romantic mill between St Märgen and Furtwangen bears the rather unwelcoming title of Hexenloch or "witch's den". Built in 1825 it has been in the same family for several generations. The mill is extremely popular – not least with model railway enthusiasts, many of whom have it as a Faller model on their layout.

Below:
St Märgen, perched on a ridge between the Feldberg and Kandel mountains, is a famous place of pilgrimage and also where the Black Forest Fuchs or fox originates from, a robust draft horse with chestnut colouring.

Top right:
Legend has it that a deer being hunted by a knight from Falkenstein Castle once managed to leap across the wide chasm of the Höllental and escape its pursuer. Immortalised in bronze, it now marks the entrance to the gorge.

Once the monastic church of Augustinian canons, the present parish church of St Märgen and affili- ated monastery were founded on the initiative of cathedral dean Bruno of Strasbourg in 1118.

The centre of St Märgen is a riot of elaborate half-timbering. Every three years the town holds its celebrated festi- val devoted to the Black Forest Horse.

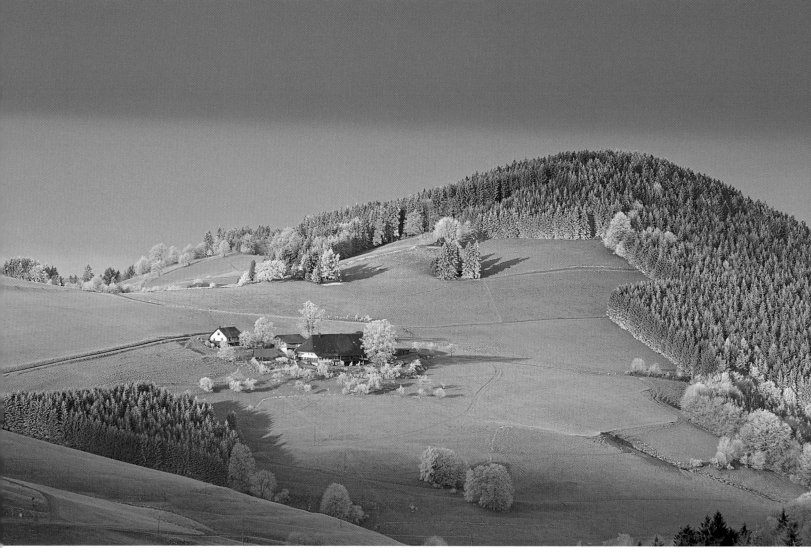

Above:
Horben, known locally
as the "sun terrace of
Freiburg", clings to the
foothills of Schauinsland
Mountain, itself a
popular ski resort. From
Horben a cable car
transports skiers and
hikers to the summit of
Schauinsland 1,284 me-
tres (4,213 feet) above
sea level.

Right:
The few beeches dotted
about the top of
Schauinsland almost
buckle under the weight
of the snow. The land
here was cleared during
the Middle Ages and
remains almost devoid
of trees.

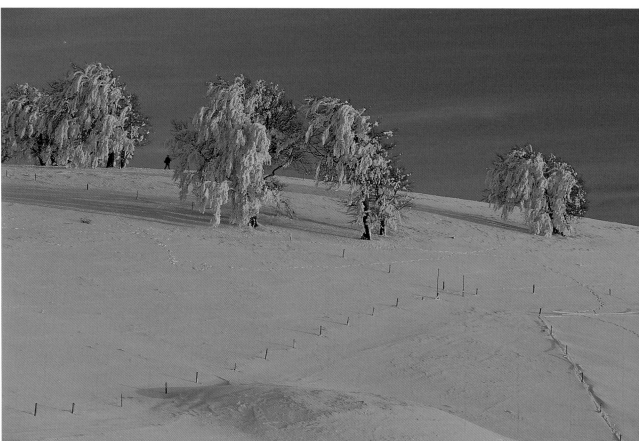

44

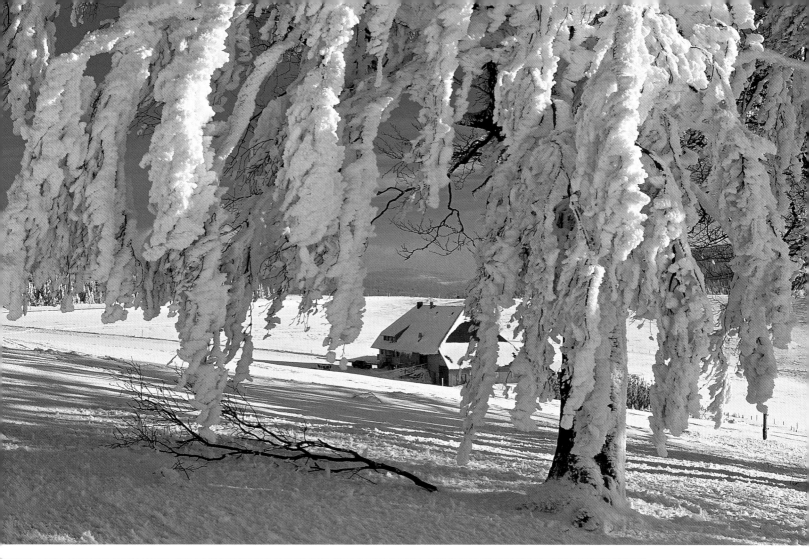

Above:
Schauinsland in the grip of winter. Buried deep beneath the snow are the plans for Cologne Cathedral and the bull issued against Martin Luther by Pope Leo X, copies on microfilm documenting great events in German history and hidden here in time capsules for future generations during the 1960s.

Left:
Schauinsland in the mist. The mountain was once mined for silver, lead and zinc, bringing riches to the city of Freiburg in the 14th and 15th centuries.

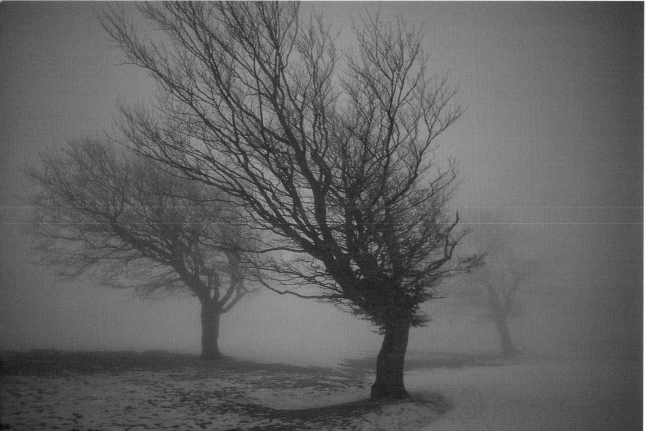

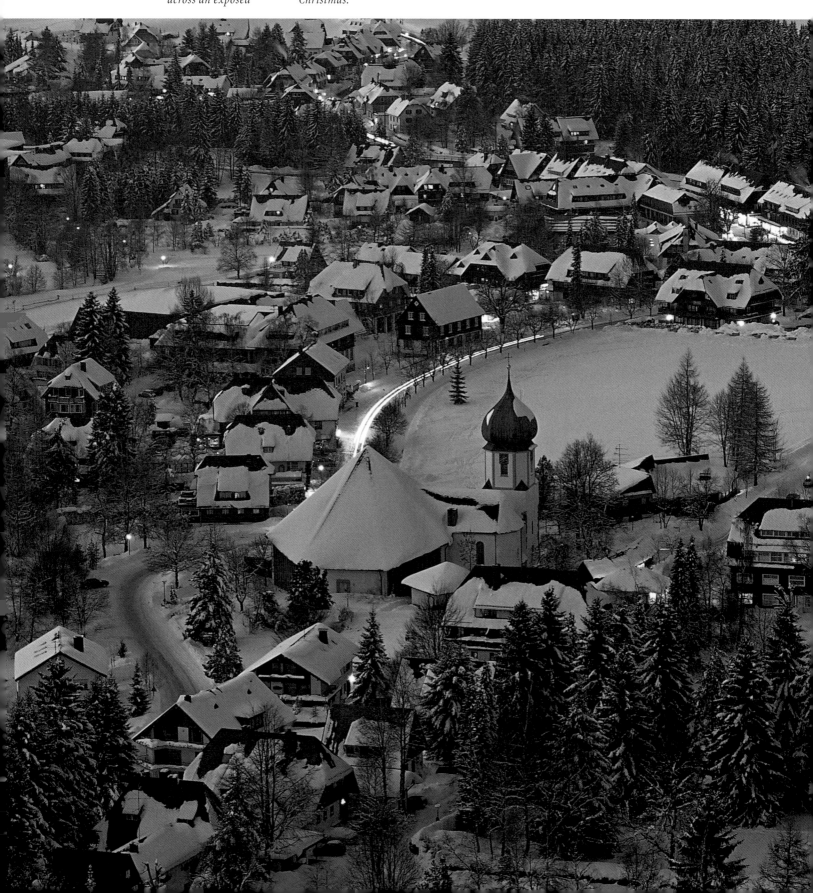

Below:
A harsh winter in Hinterzarten. The spa and ski resort sprawls across an exposed plateau high up above the Höllental, with snow not uncommon before Christmas.

Top right:
Farmhouse and chapel near Hinterzarten deep in snow. Many Black Forest farms with their typical hipped roofs date back to the 15th century.

Centre right:
Curtains aren't necessary in Hinterzarten in the winter; thick walls of icicles do just as well.

Bottom right:
A huddle of fir trees against a magical wintry sky in the Jostal.

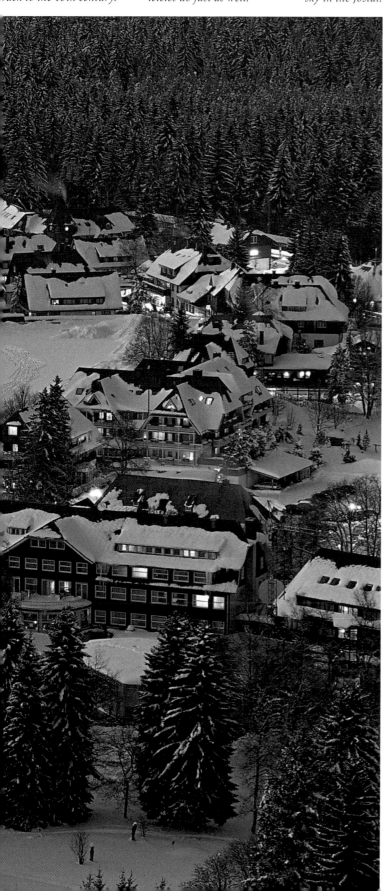

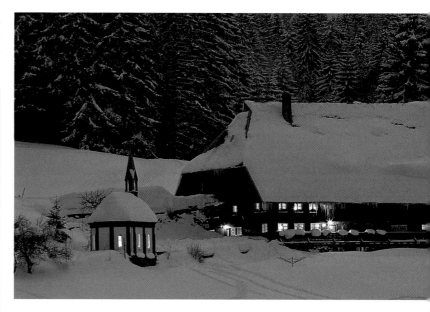

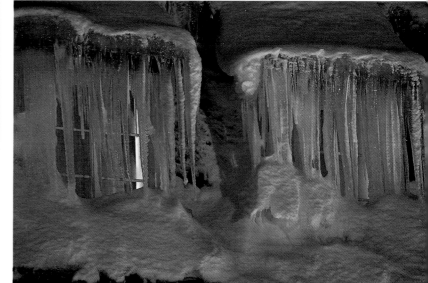

47

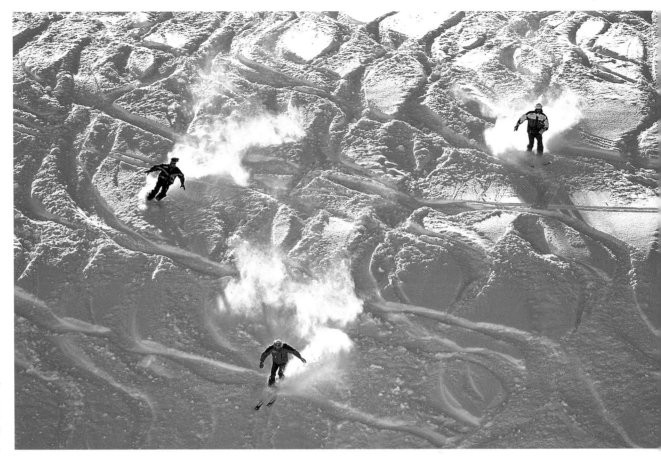

The highland valley of Langenordnach smacks of the Alps in winter with its skiers and tobogganists.

Menzenschwand at the foot of the Feldberg has three ski lifts running up from the village and five lifts on the mountain itself. There are also plenty of cross-country ski runs.

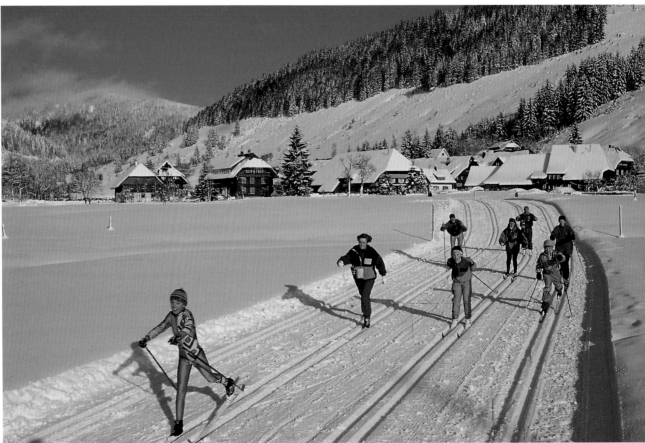

48

Left and far left:
Skiers in Hinterzarten, home to the famous ski jumper Georg Thoma who in 1960 won a gold in the Nordic combined.

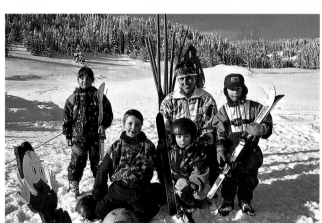

Far left:
Sledge racing in Menzenschwand. These large sleighs were once used to transport hay down into the valleys from the mountain pastures.

Left:
There's nothing like starting young if you want to learn to ski. The Black Forest has plenty of easy slopes for children and novices to this exhilarating sport.

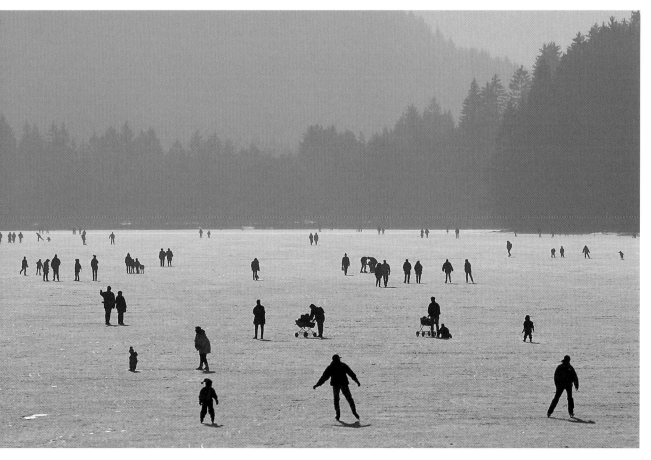

Left:
One of the great thrills of the winter sports season is ice-skating on the frozen waters of the Titisee, the largest natural lake in the Black Forest.

Right:
Not far from the western end of the Schluchsee lies the old glassmaking village of Äule. A glassworks was opened here in 1716 which operated until 1892.

Below:
Sailing on the Schluchsee. Originally much smaller, the glacial lake was enlarged in 1932 when it was dammed at Seebrugg.

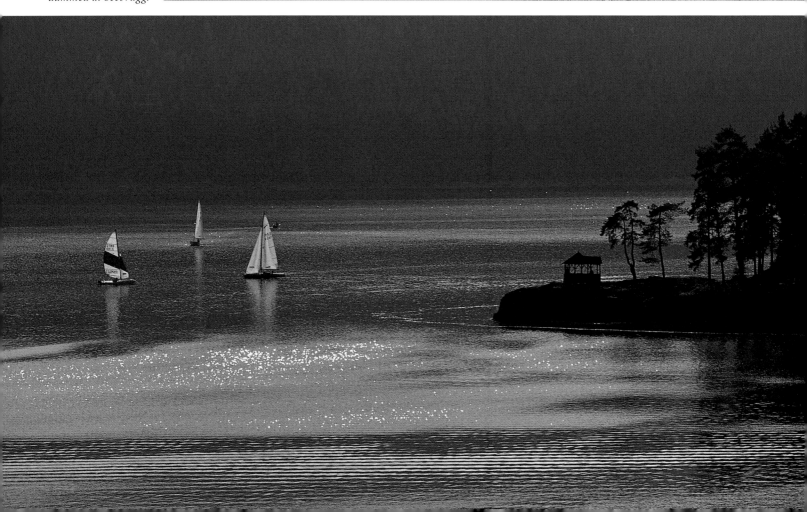

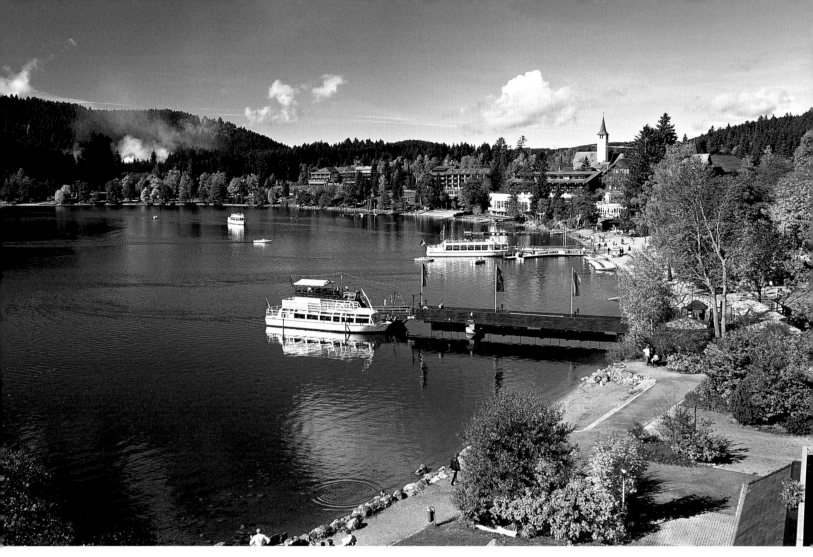

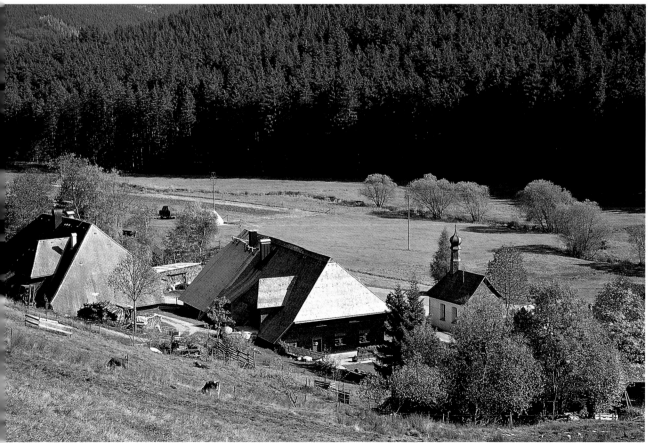

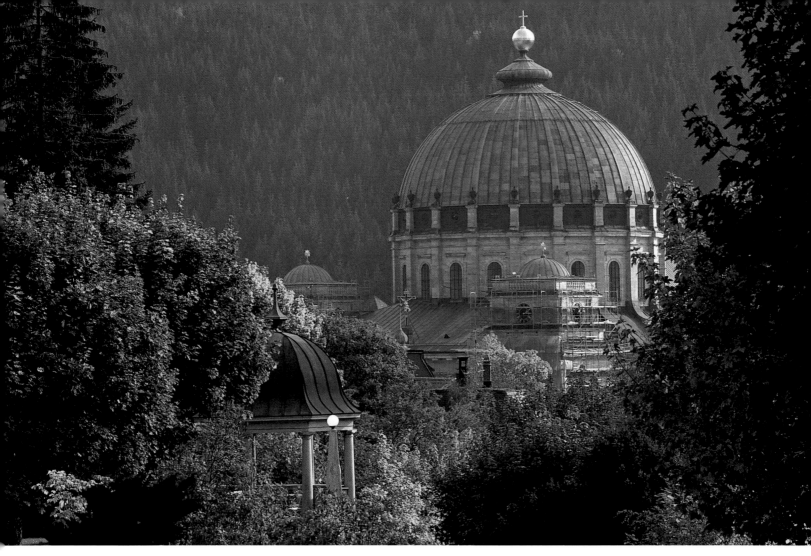

Above:
The spa town of St Blasien is positively dominated by the cupola of its monastic church, the third largest of its kind in Europe. Following a terrible fire in 1768 much of the monastery had to be rebuilt. The cathedral took on its present early neoclassical form between 1771 and 1783.

Right:
The rotunda of St Blasien. The cathedral dates back to the 9th century. A few years ago the church and its magnificent dome, which is modelled on the Pantheon of Ancient Rome, were painstakingly restored.

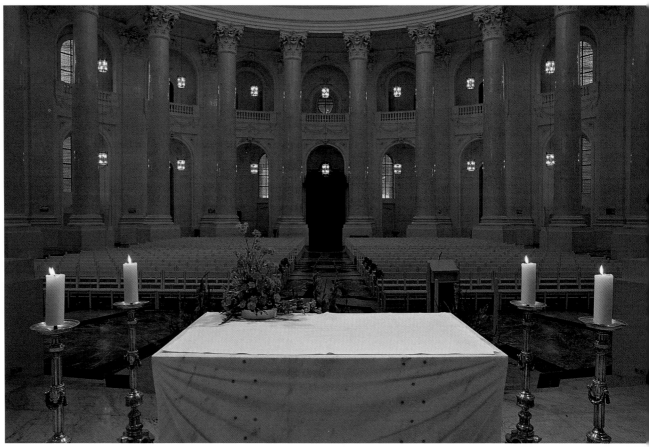

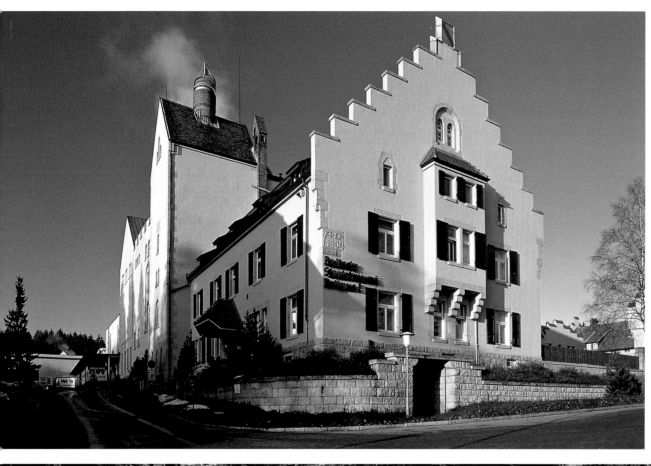

Left:
The traditional Staatsbrauerei Rothaus founded at the instigation of the prince-abbot of St Blasien Monastery in 1792. The brewery's exclusive use of pure Black Forest spring water and plenty of fresh air during the fermentation process has proved a successful formula.

Below:
The many beautiful walks around the rural village of Ibach, a few kilometres southwest of St Blasien, take you through landscapes sculpted by the glaciers and moraine of the Ice Age.

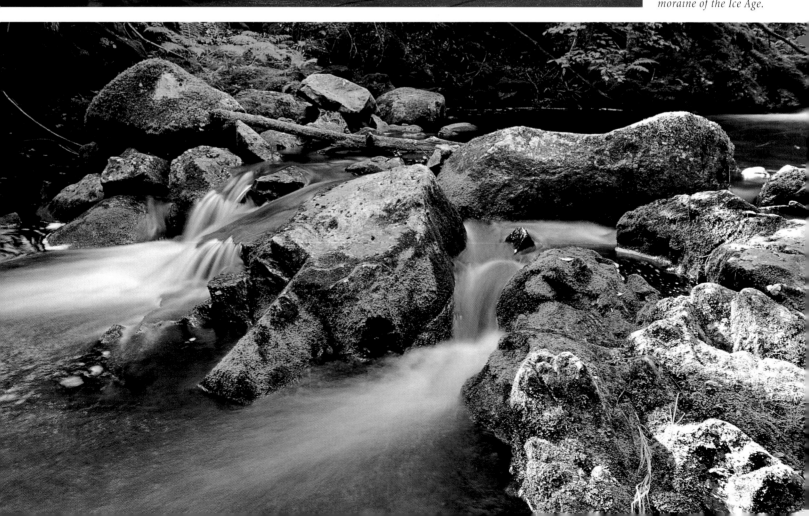

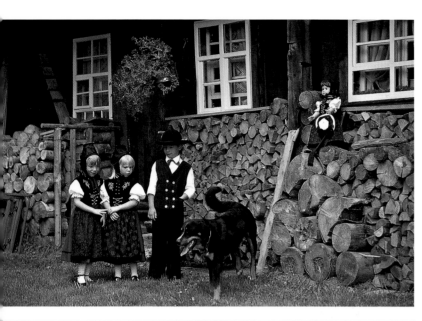

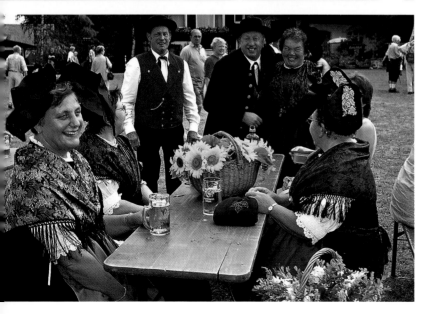

Top left:

Children in local costume in Neustadt. The boy is wearing traditional black trousers, a red waistcoat and a broad-brimmed hat. The girls are dressed in Black Forest dirndls and black bonnets.

Centre and bottom left:

Traditional summer dress in Hinterzarten. Each region has its own dress code; the famous red

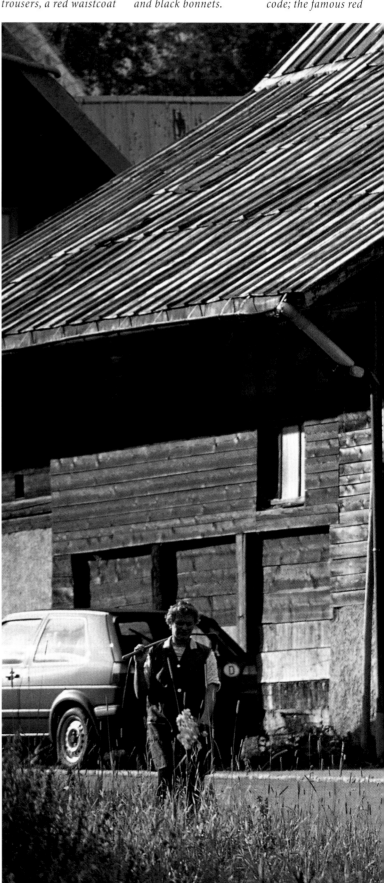

pom-pom hats, for example, are only worn by girls from the Protestant parishes of Reichenbach, Kirnbach and Gutach.

Below:

"Here I forget all my cares and my very soul embraces the tranquillity of nature", wrote artist Hans Thoma of his native Bernau, where he was born in 1839. His words still seem to ring true in this sleepy little farming community.

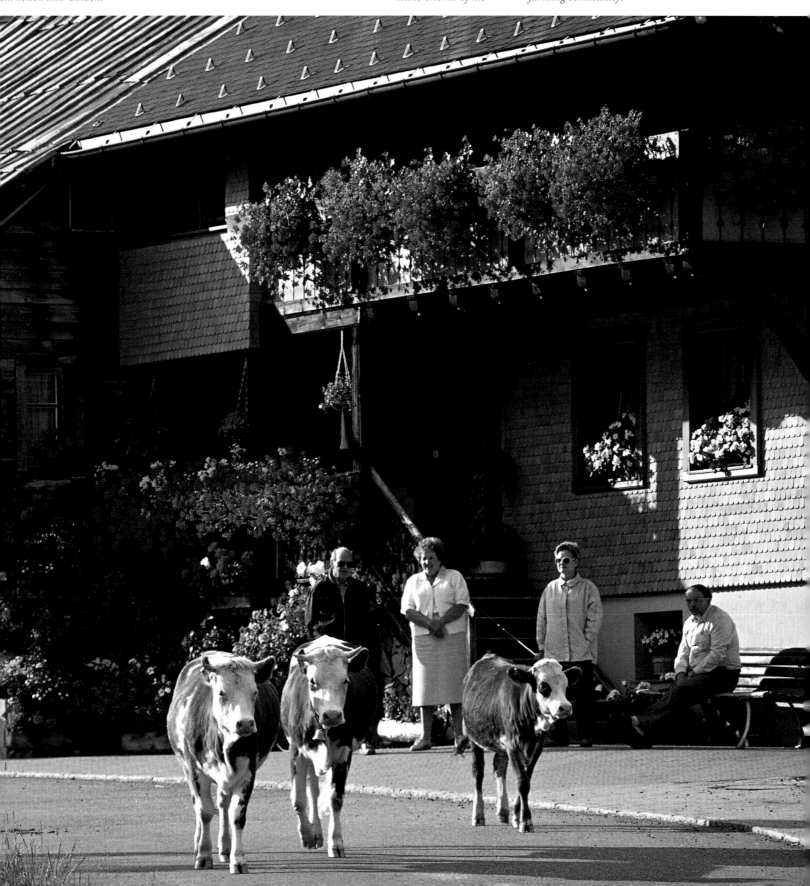

Above:
The Feldsee beneath the Feldberg is a typical lake basin carved out of the rock by the Feldberg Glacier during the Ice Age. You can hike from the lake to the summit of the mountain.

Right:
A relict of the last Ice Age: the "glacial mill" in the valley of the Schwarzbächle near Ibach.

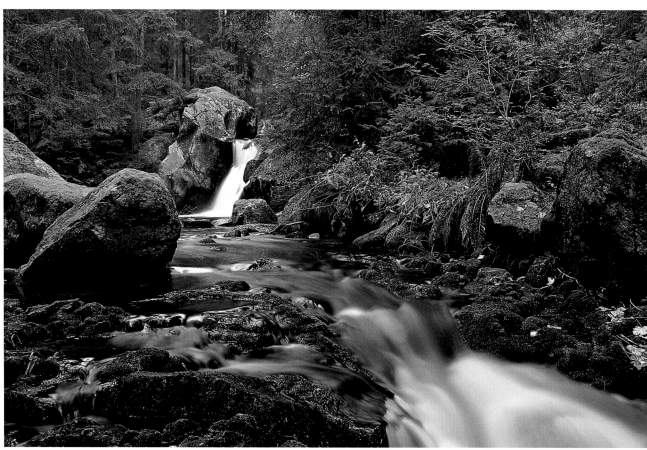

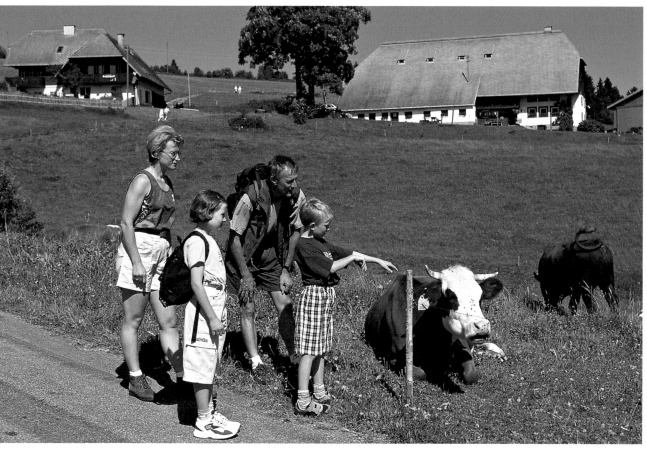

The Black Forest isn't just beautiful scenery. It's also an agricultural stronghold, with plenty of opportunities for kids (and adults) to come face to face with real live farm animals.

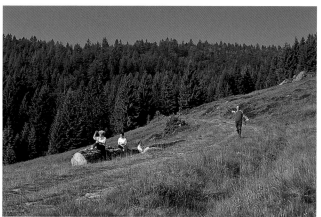

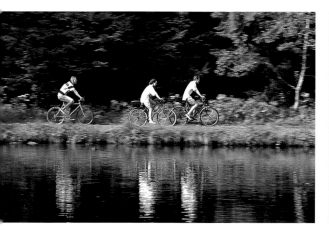

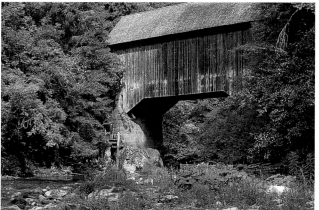

Far left:
The Wutach Gorge is a fantastic place for walkers, where a romantic trail winds for several kilometres along a river gorge under the cool, leafy canopy of a primeval forest.

Left:
Hikers taking a well-earned rest out in the open fields near Menzenschwand.

Far left:
The Black Forest's network of cycling paths has been greatly extended over the past few years, with many of the longer trails taking in spectacular scenery.

Left:
The Wutach Gorge was made a nature conservation area in 1939. With its precipitous cliffs, roaring waterfalls and rare plants and animals, it's well worth a visit.

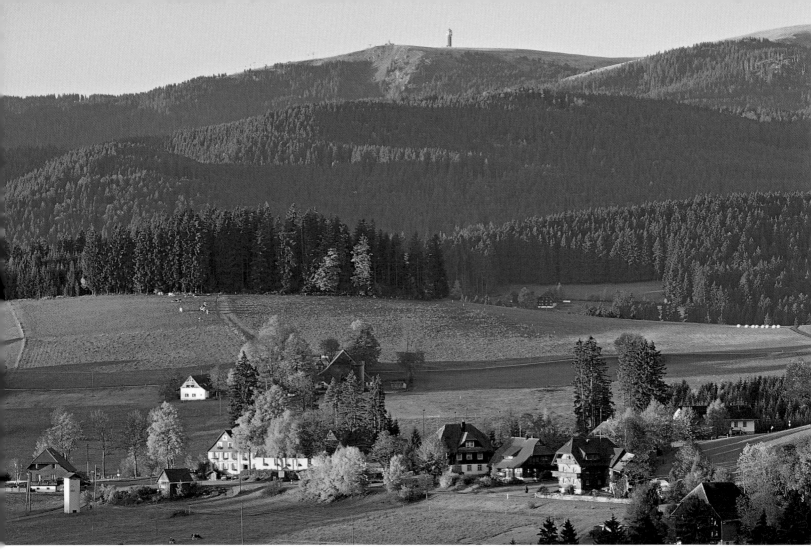

Above:
The health resort of Breitnau lies scattered across a sunny plateau high up above the Höllental Gorge, with the Feldberg behind it. Some of its farms and houses date back to the 15th century.

Right:
With the golden browns of autumn reflected in its still waters, the Windgfällweiher not far from Altglashütten is a haven of peace and quiet.

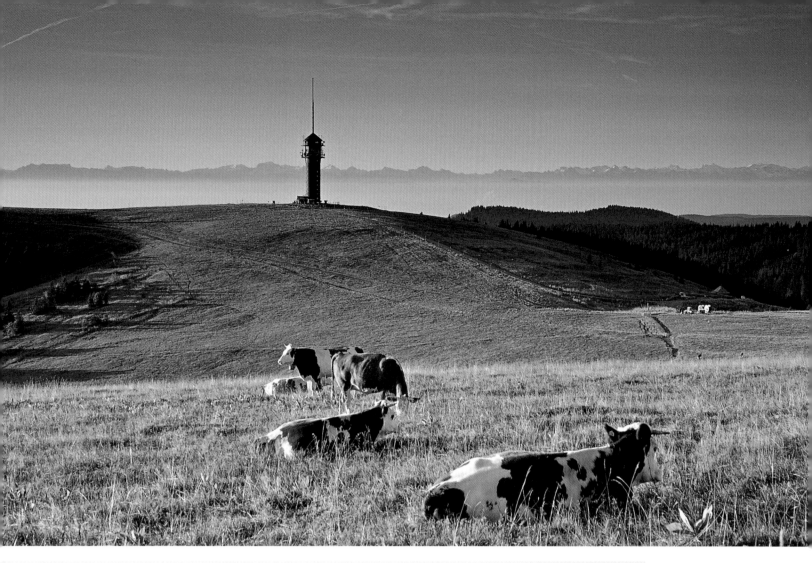

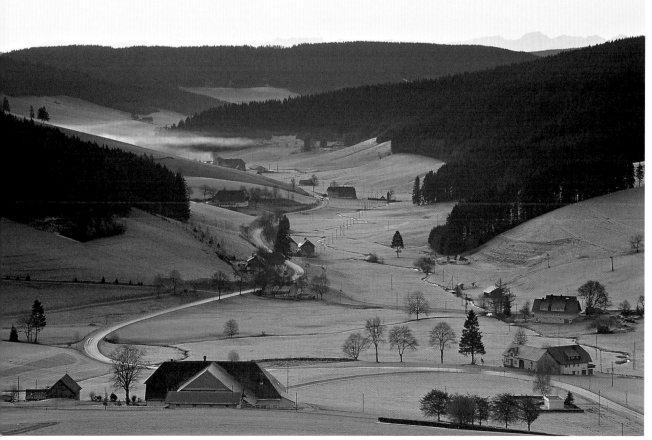

Above:
Seebuck Mountain seen from the neighbouring Feldberg. The oldest television tower in the Black Forest on its summit is a useful landmark for hikers, sticking up 1,448 metres (4,751 feet) above sea level.

Left:
Winter in Langenord-nach. The valley runs from Hölzlebruck near Titisee-Neustadt to Waldau in the north.

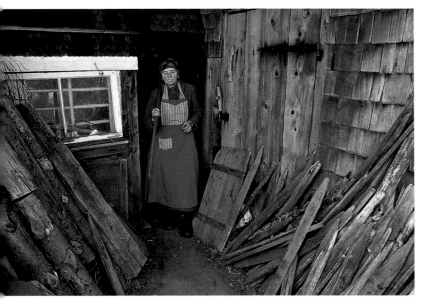

Small photos, left:
Out in the country. However idyllic the chalet farms might seem, life in the depths of the Black Forest is hard. There's wood to be chopped for the winter (top), the potato harvest to be brought in in the autumn (centre) and precious little time to sit down and put your feet up (bottom).

Below:
Most of the fields in the Black Forest are used as pasture for dairy cattle who thrive not only on the lush vegetation but also on the abundance of fresh air.

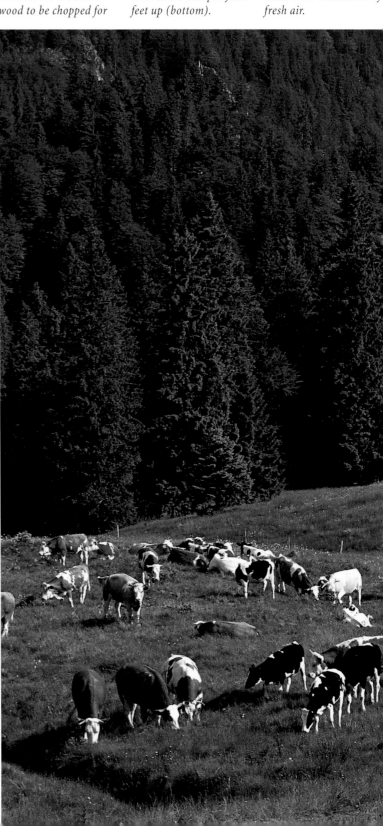

Top right:

In the olden days the brick stove in the kitchen usually didn't have a chimney; smoke collected under the vaulted ceiling where hams and sausages were hung up to dry.

Centre right:

Although not strictly speaking a working animal in their own right, cats are happily tolerated on farms to keep the mice and rats at bay.

Bottom right:

Milking the herd the old-fashioned way in Bernau.

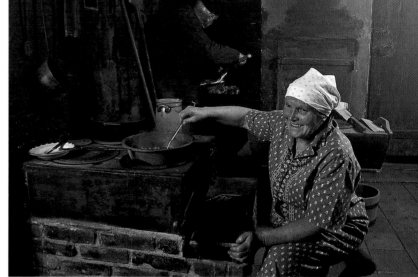

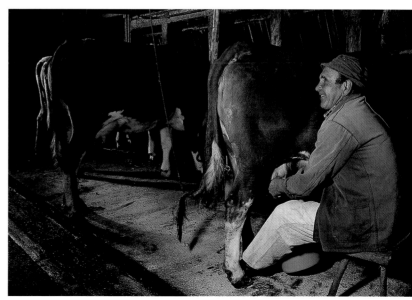

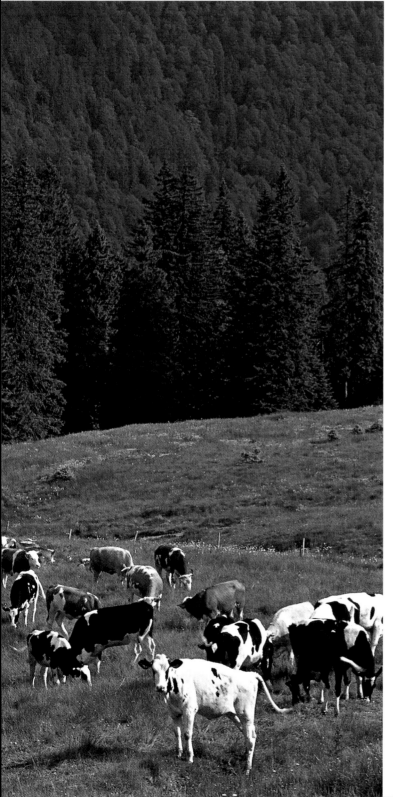

61

"**A**s remote as a distant planet", not a farm but a "time machine": the opening credits of a four-part documentary recently shown on German television sound like the introduction to a science fiction movie rather than the overture to an exercise in living history. For three months a rural farmstead in the idyllic valley of the Münster in the Black Forest was home to a family from the bustling German capital of Berlin. Sounds romantic, you might think. The catch: they were expected to live in the year 1902, facing all the hardships and often impossible challenges such an undertaking inevitably presents. One person's dream is another's nightmare; millions of viewers ensconced in their comfortable armchairs were glued to their screens as the chosen few struggled to

cope with the hay harvest, the slaughtering of farm animals and many other unfamiliar and frequently unpleasant chores. Where over a hundred years ago the farmers of the Black Forest managed their lives along the lines of "work first, then play", their 21st-century counterparts failed miserably on several counts. As infotainment "Schwarzwaldhaus 1902" was a hit, however, the stuff of a mediocre educational film proving a dramatic success and earning authors Rudolf Schlenker and Volker Heise the coveted Grimme-Preis in 2003.

ALL UNDER ONE ROOF

Life in centuries past meant strict discipline, extremely hard work and making the best of what you had. The farmer's greatest

Left:
Farm on Thurner Mountain. The slope leading onto the upper floor of the barn is also a labour-saving invention, allowing hay to be forked straight down from the rafters into the stalls below.

Below:
Black Forest farm in the Jostal. The less distance you have to walk, the lighter the work load, which is why typical farms have the house and barn under one roof.

Top right:
Thankfully modern technology has done much to relieve work on the farm and can be fun too; riding out on the tractor for the hay harvest is an opportunity not to be missed!

Centre right:
Spinning at the Dutch stove. The Resenhof Museum of Farming in Bernau documents the Black Forest of the past for the people of the present.

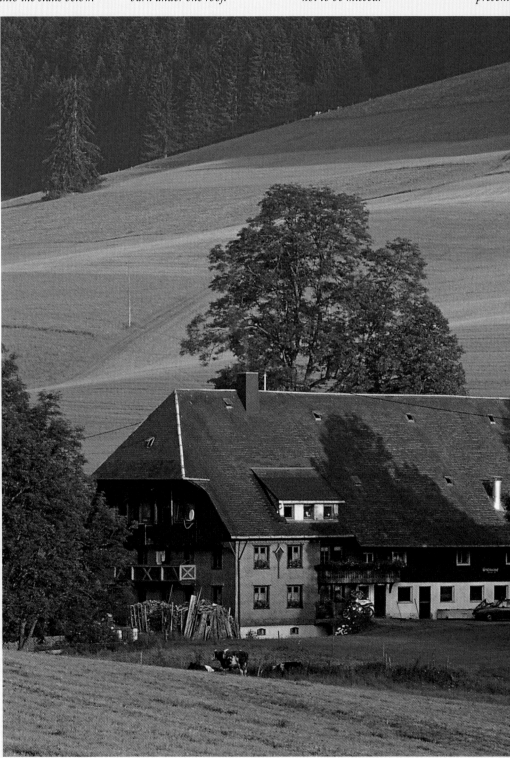

BLACK FOREST FARM

Bottom right:
The Hüsli Museum in Grafenhausen-Rothaus. Hüsli or "the little house" was assembled from various bits of older farms in 1912.

Far right:
A farm in Wembach. Long ago the roofs were thatched with straw; because of the risk of fire these are now only found in museums.

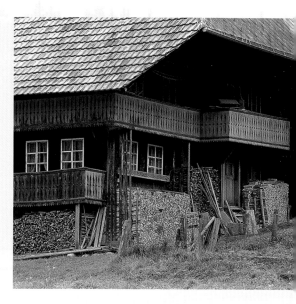

asset was his Black Forest chalet, built to cope with the raw climate to which his family and livestock were constantly exposed. The narrow end of the roof braced the elements, giving prevailing winds the smallest possible area for attack. Farmhouses were traditionally built of wood and had low, overhanging roofs. In the hall house people, animals and crops all found shelter under one roof. Various labour-saving measures were an all-important consideration; buildings were designed with a ramp of earth or wood sloping up to the top floor, enabling farmers to store the harvest exactly where it was needed. The hay could then be forked straight down into the barn below. In the winter life centred around the farmhouse kitchen and living room, the only two heated rooms in the house. The Dutch stove in the living room was fired from the kitchen. Hot air rose up through a small flap in the ceiling into the bedrooms above. In winter the main room was used for handicrafts,

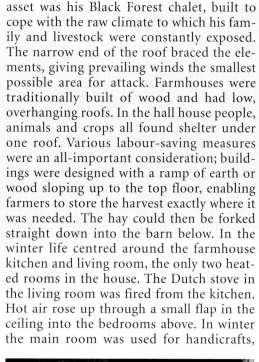

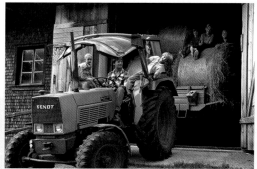

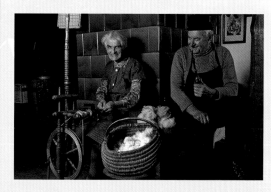

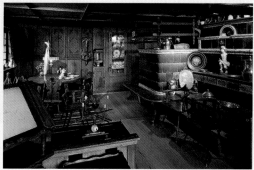

such as sewing, clockmaking and woodcarving, providing farmers with an essential additional source of income. The typical Black Forest chalet didn't have a chimney; smoke from the Dutch stove and kitchen range collected in a huge chimney hood in the kitchen. This was where sausages and hams were hung up to cure. The warm air the hood gave off filled the entire upper storey, guarding the hay against bacteria and impregnating the wooden rafters of the roof. Historians have noted that these historic building materials "age well and through use and weathering do not become shabby but develop their own unique qualities". Today such attributes are completely desirable in the sudden demand for ecologically-sound building materials.

ROMANTIC CHALET FARMS

The tall chalets of the Black Forest are the oldest types of house in the region, where the load-bearing beams reach from the floor to the ridge of the roof. Hippenseppenhof in Furtwangen-Katzensteig dates back 400 years and is the oldest museum farm in the Black Forest. Todtmoos's Heimethuus with its wooden shingle roof is over 250 years old and now serves as a local museum. Another romantic chalet farm, the Hüsli Museum in Grafenhausen-Rothaus, goes back to just 1912 but is in fact a compilation of several much older farms. Its low roof, cosy interior with painted ceilings and cupboards and ancient doors and wooden floors make it a set designer's dream and it has a reputable television career behind it as the home of Professor Brinkmann in the long-running German soap "Die Schwarzwaldklinik".

Below:
The Black Forest has the highest waterfalls in Germany. The seven cascades of the Triberg Falls on the Gutach River have a drop of no less than 162 metres (532 feet).

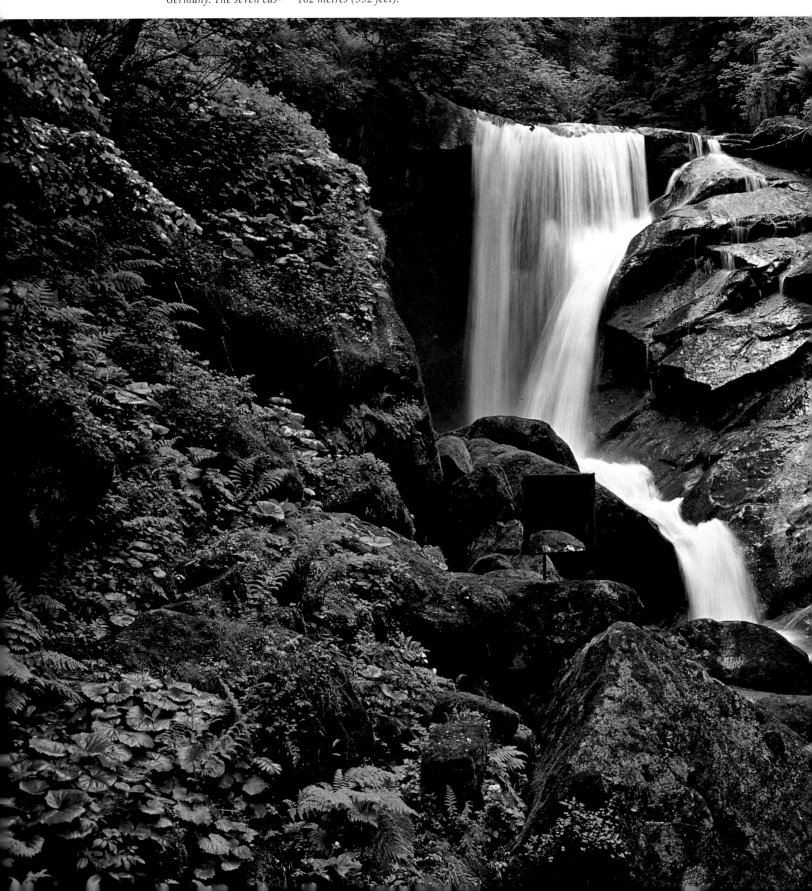

Top right:
The main source of the
River Danube, the Breg,
rises at the Kolmenhof
restaurant in the high-
lands near Furtwangen.

Centre right:
The Balzer Herrgott, a
sandstone bust of Christ
entwined by the roots of
a beech tree just outside
Gütenbach, is a place of
quiet meditation.

Bottom right:
The ornamental
balustrade encircling
the "official" source
of the Danube at
Donaueschingen was
designed in 1875 by
Adolf Weinbrenner.

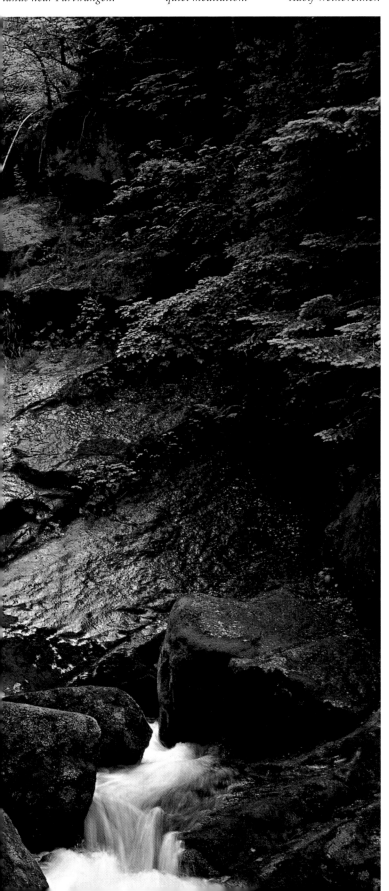

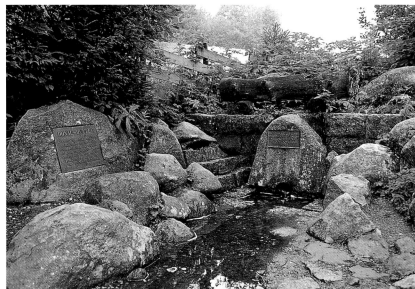

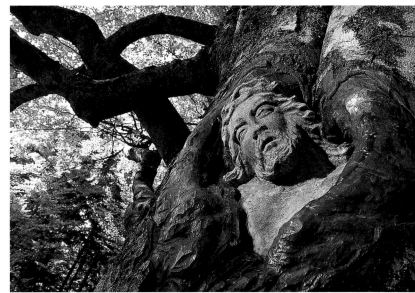

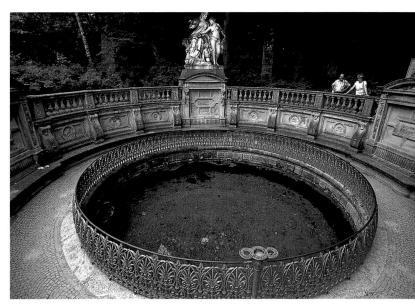

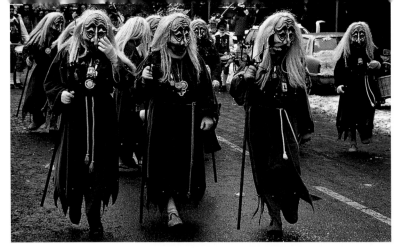
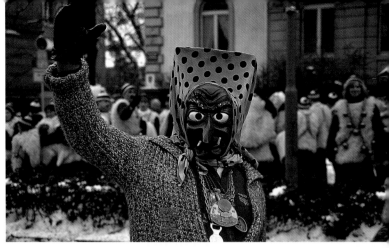

Right:
The Narrensprung procession in Rottweil on the Monday before Shrove Tuesday. In 1754 just 119 were members of the local fools' guild; today there are over 6,000. Between 20,000 and 25,000 spectators flock to the town on the River Neckar for the Mardi Gras revelries each year.

Small photos:
"Better foolish once a year than mad the whole year long" is the motto of Alemannic carnival or "Fasnet", the "fifth season" of the year. The whole region is plunged into a light-hearted state of emergency, as seen here in Freiburg (small photos, top), Elzach (far centre right) and Rottweil. The devils, witches and evil spirits who take over the town have a long tradition; "Fasnet" is recorded as having first been cele-brated in Freiburg in 1283 and in Elzach in 1530. The "Schuddig" of Elzach depicted here is a winter demon in a flaming red coat, three-cornered hat with red pom-poms and a terri-fying wooden mask.

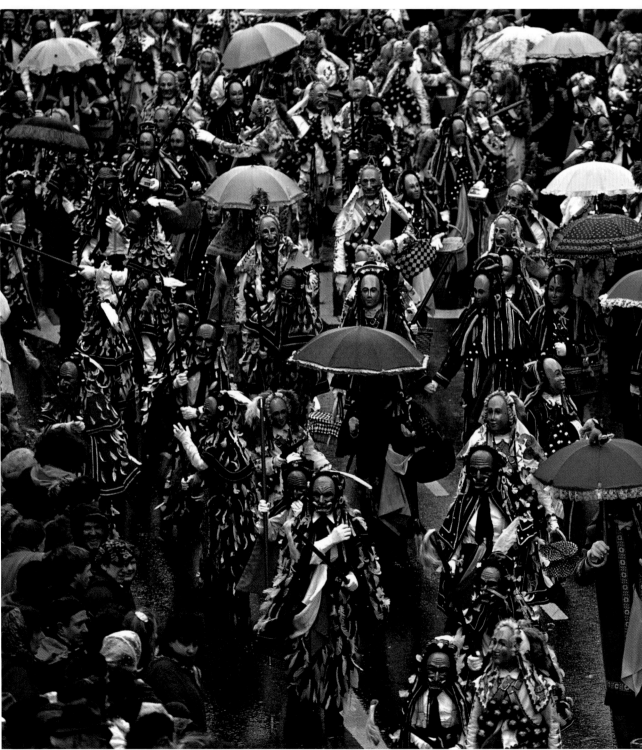

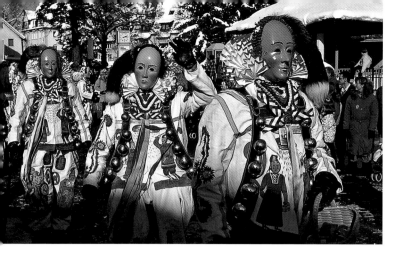

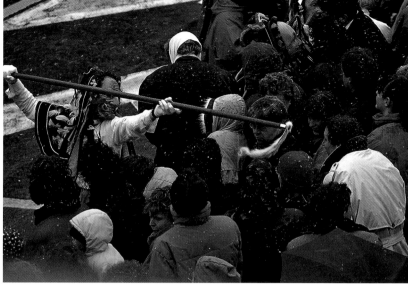

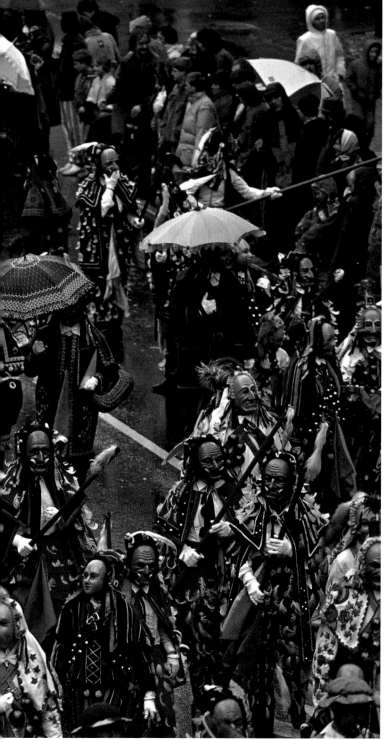

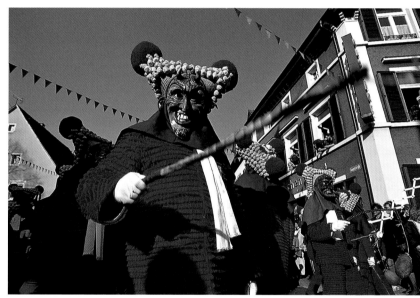

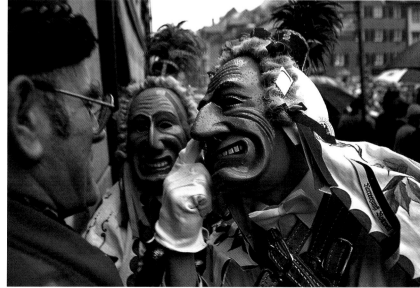

"THE FOOL DOTH THINK HE IS WISE, BUT THE

In the words of the Bard this makes the Black Forest a very wise place indeed – at least in the run-up to Lent, when nearly the entire population shed their "sensible" clothes for the traditional fool's dress, taking to the streets for a long weekend of merry revelry. Young and old from both the traditional and more radical carnival camps are united in their new-found role as "Fasnet" fools, joining forces to escape the humdrum of everyday life – for a few days at least. And celebrate they do, long and hard, driving away the "wild man" Alpine and Alemannic tribes once saw as the demon of winter who haunted their mountains and forests.

To use its correct Alemannic term, "Fasnet" (Mardi Gras) is the manifestation of centuries of local custom and tradition governed by a strict set of rules. Recently its popularity has positively boomed, with new associations of masked revellers being formed at the drop of a jester's cap. Established clubs are, however, a

their whips, rattles and bells like the devil possessed in a valiant effort to drive out the evil spirits of winter.

NARRIII! NARROO!

The fun all starts on "Dirty Thursday", the Thursday before Shrove Tuesday, when the fools storm the town hall and take over local government. This is the night when the

Left:
Here young men have built a huge celebratory bonfire to light discs of wood they then send hurtling down into the valley with sticks.

Far left:
These expertly carved fools' masks in Elzach are veritable works of art.

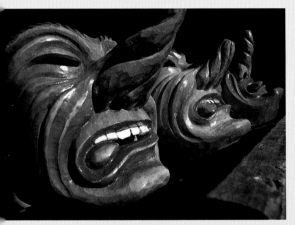

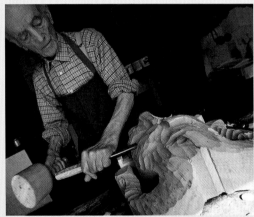

little concerned at the increasing influx of "foreign elements" from Rhineland "Karneval" and Mainz's "Fassenacht", warning that: "Red Indians, cowboys, Negroes, Smurfs and other such characters are not part of our local tradition." Indeed, the jolly jesters of the Black Forest don't wear anything as simple as a costume at all, and certainly not a shop one; they wear a "Häs". No self-respecting joker would ever don a cheap, plastic mask; no, here "Fasnet" masks are carved from wood by skilled local craftsmen. And no "Häs" would be complete without an entire wardrobe of props; bells, rattles, swords, magic wands, extending scissors, mirrors, brooms and umbrellas are an absolute must. Safely disguised in their "Häs", law-abiding citizens become the wild things of the woods. At traditional carnival parades they throw all care to the winds, leaping around with

streets are filled with people in their pyjamas taking part in the nocturnal Hemdglonker parade, answering wild cries of "Narriii!" with equally raucous shouts of "Narroo!". The traditional strongholds of Swabian Alemannic "Fasnet" are the towns of Waldshut-Tiengen, Laufenburg, Bad Säckingen on the High Rhine and Bonndorf in the Southern Black Forest. Laufenburg boasts the oldest guild of fools dating back to 1386, with Bad Säckingen (1425), Waldshut (15th century) and Tiengen (1503) not much younger. Waldkirch, Kirchzarten and Elzach near Freiburg are also firmly in the grip of the silly season; the "Schuddige" or red devils of Elzach in particular are famed for their wild abandon. Up until Shrove Tuesday the entire region is in a state of frivolous emergency. Rottweil's highest feast day begins at 8 o'clock sharp on

WISE MAN KNOWS HIMSELF TO BE A FOOL."

(As You Like It, William Shakespeare)

Bottom left:
A maskmaker's workshop in Elzach where traditional designs hundreds of years old are chiselled out of wood.

Below:
»Scheibenschläger« in Buchenbach. The tradition of beating discs of burning wood down into the valley with a long stick is still upheld in the Breisgau, on Lake Constance, in the Allgäu and in South Tyrol in Italy.

Right:
The fountain of fools in the carnival stronghold of Elzach celebrates the silly season all year round.

Bottom right:
On the Sunday before Shrove Tuesday jesters and jokers from all over the Black Forest congregate for the grand parade in Elzach.

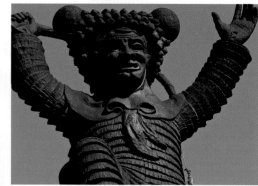

the Monday before Lent with the Narrensprung procession, in which a whole host of scary spirits parades through the streets in all their gruesome finery. (The show's repeated twice the following day for those who missed anything – for whatever reason.) In other parts of the Black Forest the spirit of "Fasnet" is ceremoniously burned on Shrove Tuesday and the entire region jovially commiserates the passing of the fifth season of the year in local pubs and restaurants.

The entire region? Well, not quite. One indomitable corner of the Southern Black Forest still holds out against the party-poopers of the north. While others are back at work nursing their hangovers, the pocket of land between Germany, France and Switzerland bravely parties on. The first Sunday in Lent is traditionally when cries of "Nariii! Narroo!" and the brass and drums of "Guggenmusiker" imported from Switzerland echo through the streets. Fools and demons from the Black Forest and beyond don their "Häs" once more for the grand parade in Weil am Rhein, the loud and colourful menagerie giving winter the final heave-ho. On Sunday evening huge bonfires light up the hills of the High Black Forest and the Markgräfler Land. "Scheibenschläger" send discs of burning wood hurtling down into the valleys like miniature suns, bringing tidings of spring in glorious triumph over the bitter cold of winter.

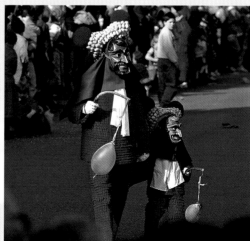

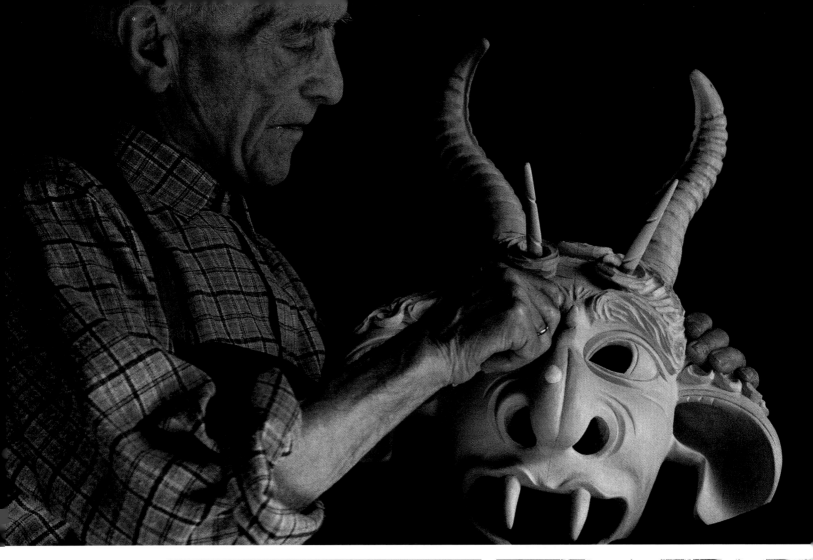

Above:
Many of the traditional masks worn for "Fasnet" are carved by hand – and many are quite scary, like this one in Elzach.

Right:
Fools at the Narrenschopf Museum of Alemannic Carnival in Bad Dürrheim. The collection has over 400 life-size models dressed in the traditional garb of southwest German and Swiss "Fasnet" revellers.

Far right:
The baroque palace once belonging to the counts of Mörsberg in Bonndorf is also a carnival museum.

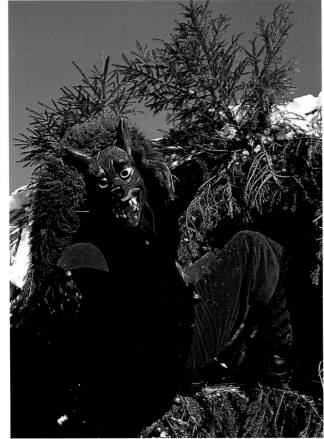

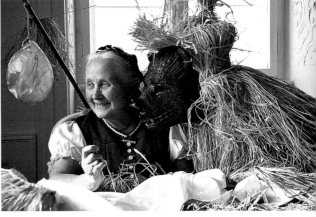

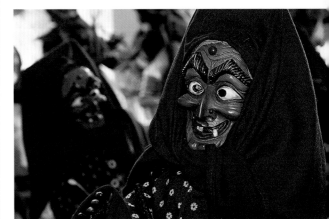

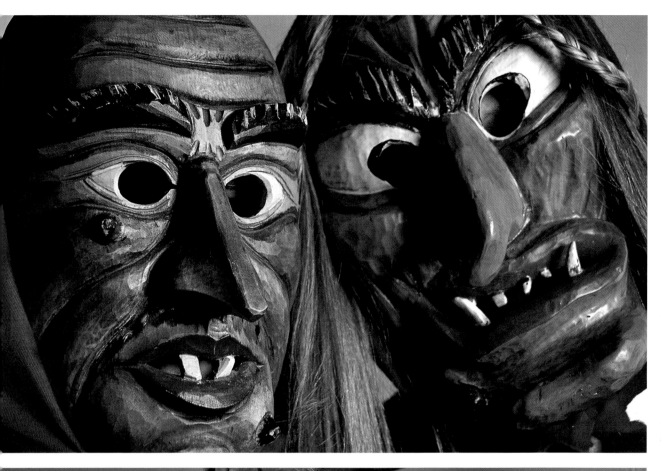

Each guild of fools has its own special mask depicting characters from local legends and fables. There are witches, demons and wild men of the woods and the slightly less terrifying faces of the "Weißnarren" or white fools.

Carnival masks are traditionally made of lime wood and worn with a "Häs" costume made of rags, fur or sacking which has bells sewn onto it.

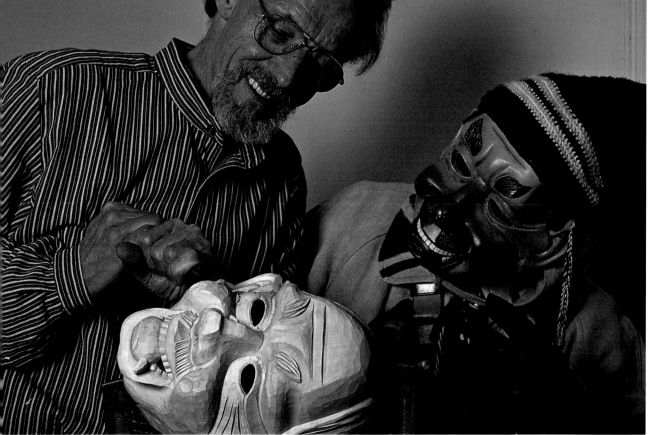

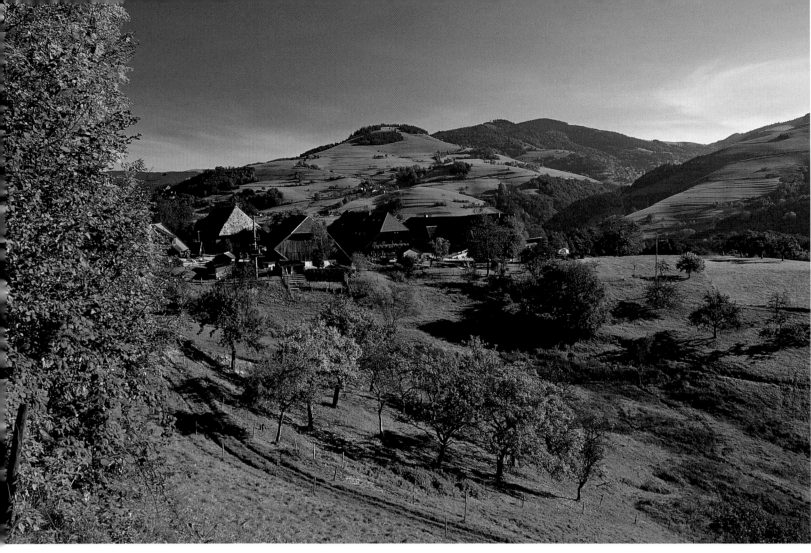

Above:
Oberhepschingen lies high up above the Wiesental and has splendid views of the surrounding countryside and the Feldberg. The River Wiese rises here on the southwest slope of Seebuck Mountain, flowing into the Rhine near Basle.

Right:
The idyllic valley of the River Wiese has one health resort after another embedded in lush green forest, with Todtnau (shown here) the largest of them all.

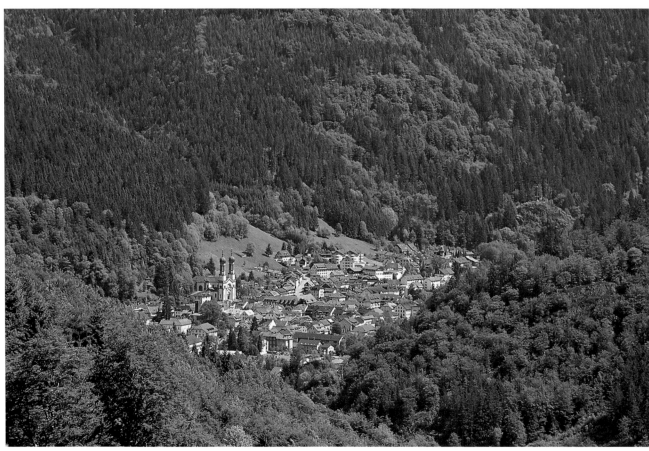

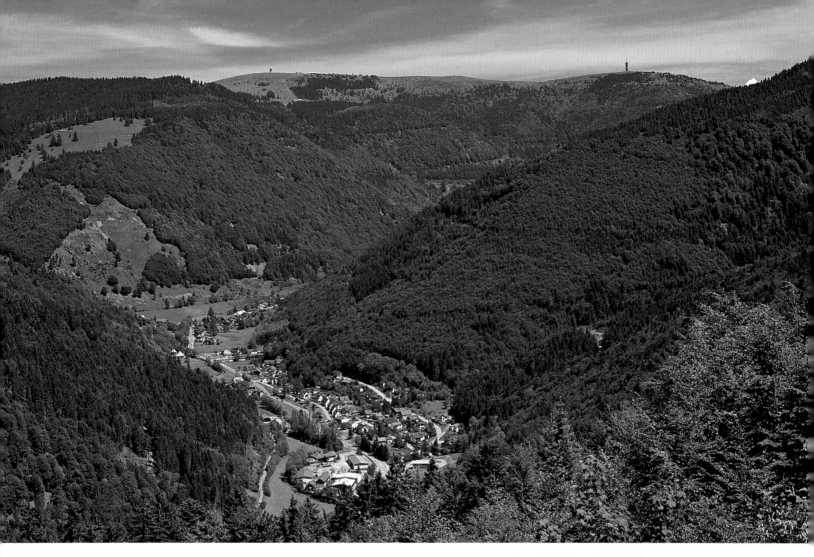

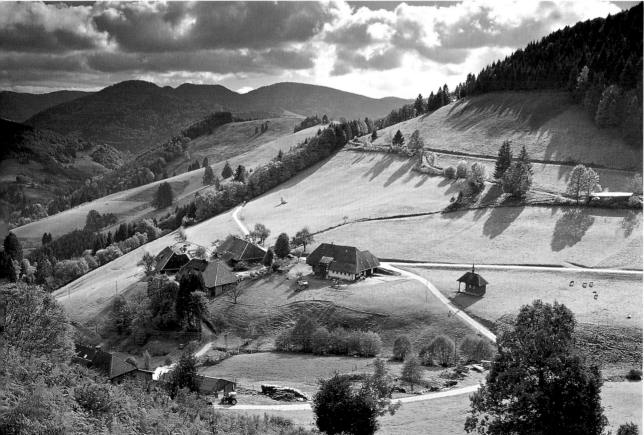

Above:
The smaller villages of the Wiesental are relatively few and far between. Hausen is one, the birthplace of poet Johann Peter Hebel with a museum dedicated to his life and work.

Left:
The valley of the River Wiese, 80 kilometres (50 miles) long, was formed during the last Ice Age by an enormous glacier.

Below:
In our grandfather's day and age blacksmiths were not uncommon. Now redundant in many parts of our modern world, the Black Forest still has some working smithies.

Bottom:
Other trades are now only practised in museums. This cooper is giving a demonstration at the Resenhof Museum in Bernau.

Below:
In the Wiesental willow baskets are still woven by hand.

Bottom:
A stove fitter plies his trade at the Resenhof Museum in Bernau.

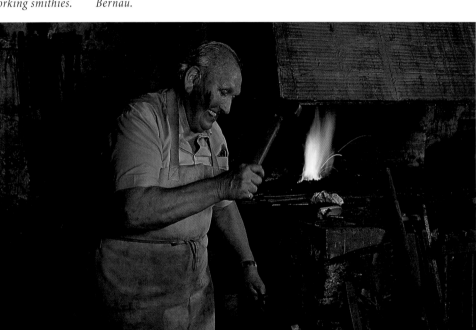

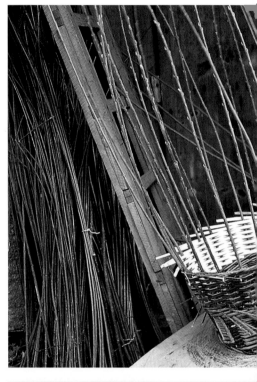

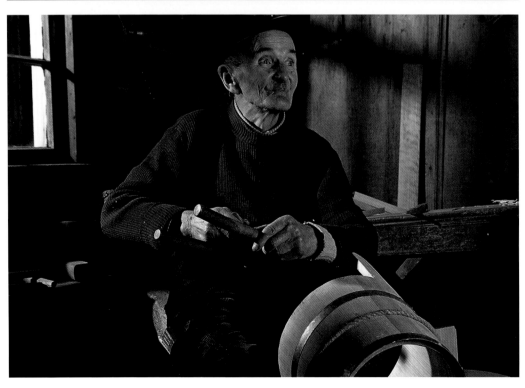

Below:
Life in the high-lying
Bernau Valley was long
dominated by wood.
The art of making wood-
en tiles is, however, now
almost forgotten.

Bottom:
The museum at the
Resenhof is dedicated to
a number of trades, but
particularly to carpentry
and woodcarving.
This cheerful craftsman
is making boxes out of
very thin strips of wood.

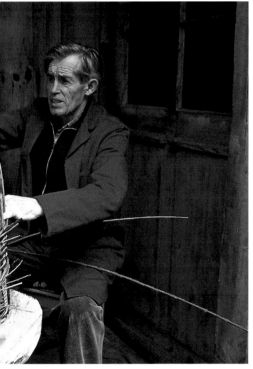

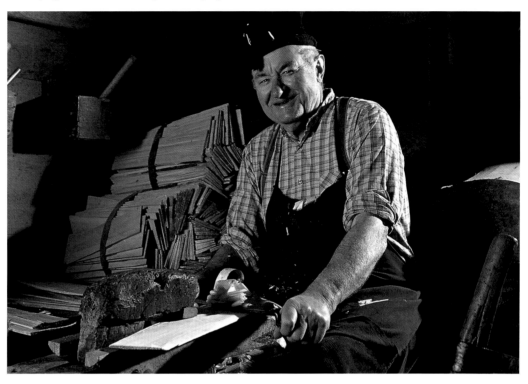

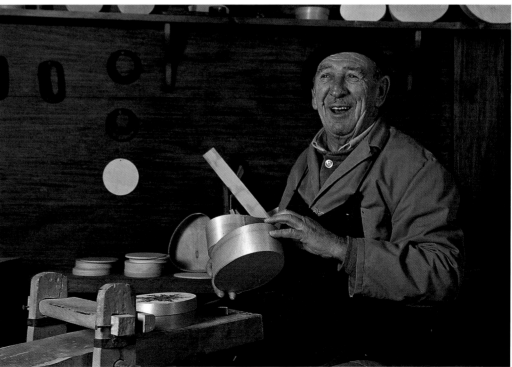

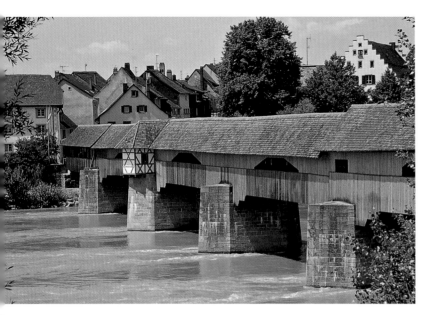

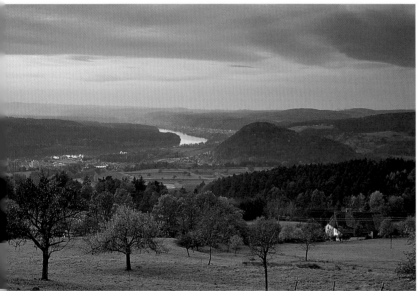

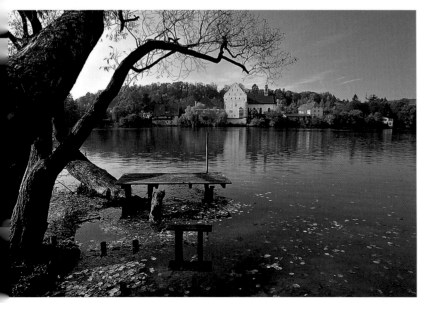

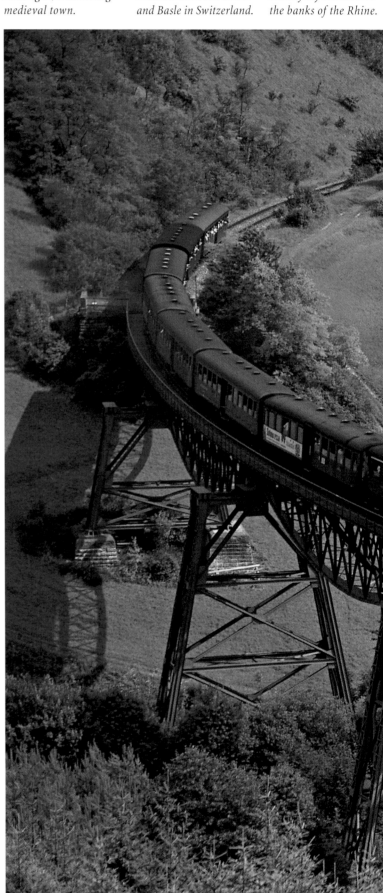

Below:
The Sauschwänzlebahn (the "pig's tail railway" running through the Wutach Gorge) is so called because of the many twists and turns along its track. With a total length of 26 kilometres (16 miles), the route covers a distance of just 10 kilometres (6 miles).

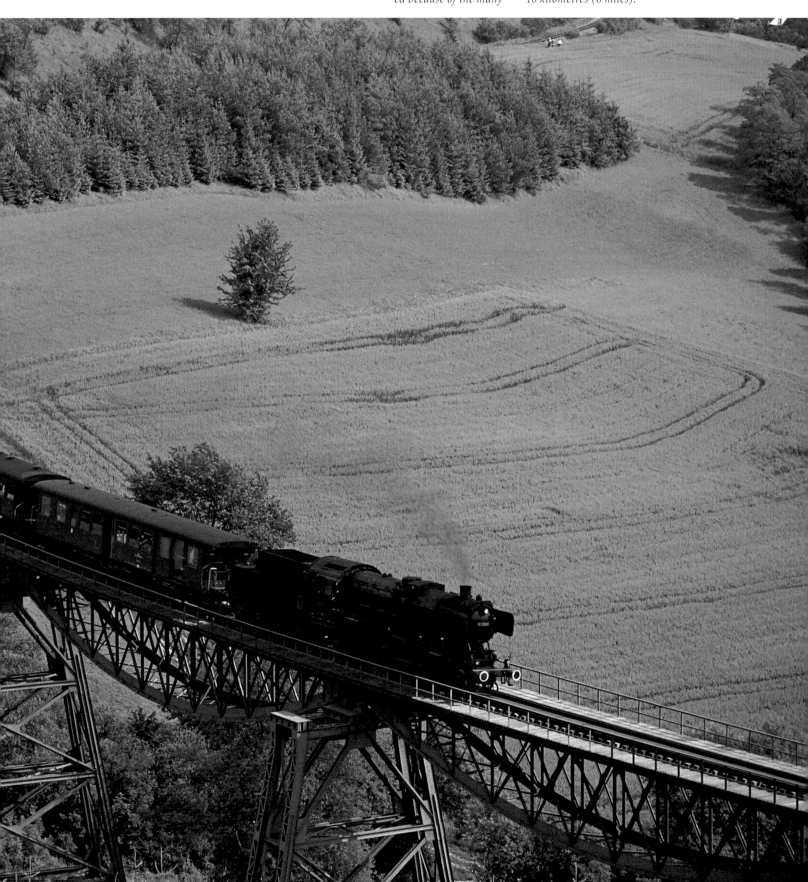

Page 78/79:
View from the summit of Belchen Mountain. On a clear day you can see the Rhine plateau and France with Alsace and the Vosges to the west, with the Swiss Jura and occasionally even the snow-capped peaks of the Alps to the south.

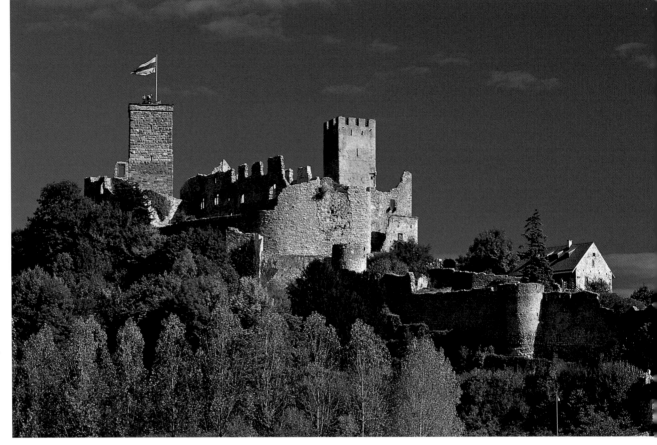

Burg Rötteln, the largest medieval castle in Upper Baden, is north of Lörrach. First mentioned in 1259, after a turbulent history it was finally destroyed by the French in 1678.

Southeast of Lörrach is the village of Inzlingen with Schloss Reichenstein, a moated castle which was turned into a comfortable palace during the 16th century.

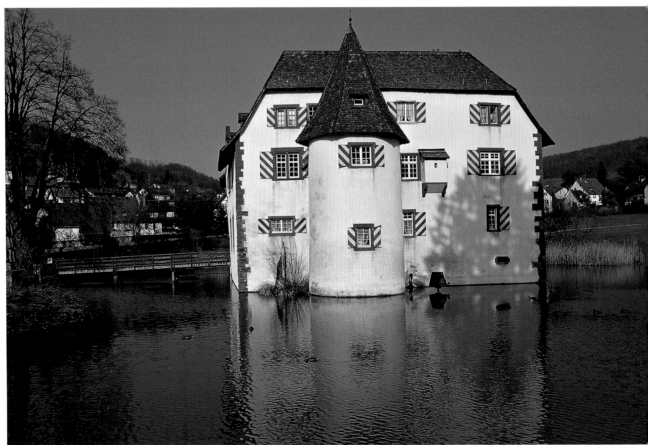

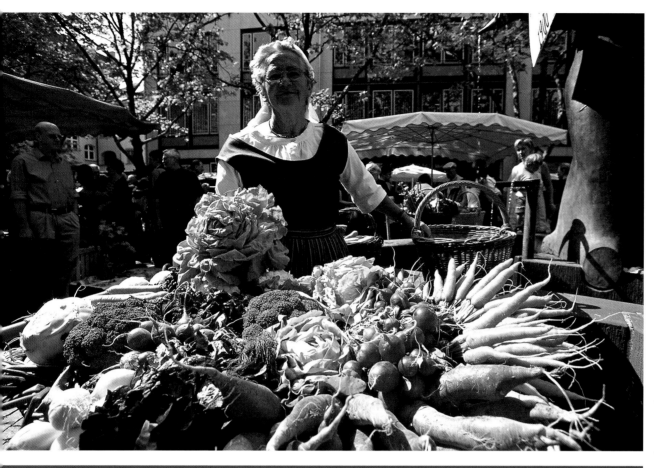

Crisp lettuce and crunchy carrots are just some of the products at Lörrach's market, all of them recently harvested from the surrounding farms and sold here with a friendly smile.

The Vitra Design Museum in Weil am Rhein is one of the world's leading museums of its kind. It was opened in 1989 in a building designed by Californian architect Frank O Gehry and focuses on the history of and current trends in industrial furniture design.

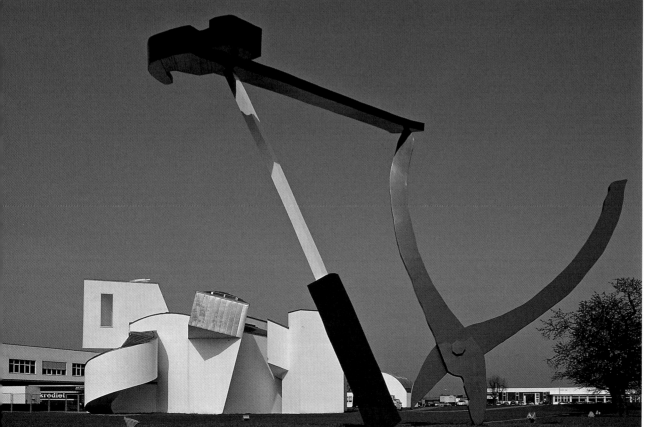

Above:
On crisp autumn days the schnapps made from the fruit of these cherry trees warms the heart with the smell of summer.

Right:
Not far from Sulzburg in the Markgräfler Land lies the idyllic wine village of Laufen. Its long history proved relatively uneventful until 1926 when the Countess von Zeppelin began nurturing her spectscular collection of irises and poppies here.

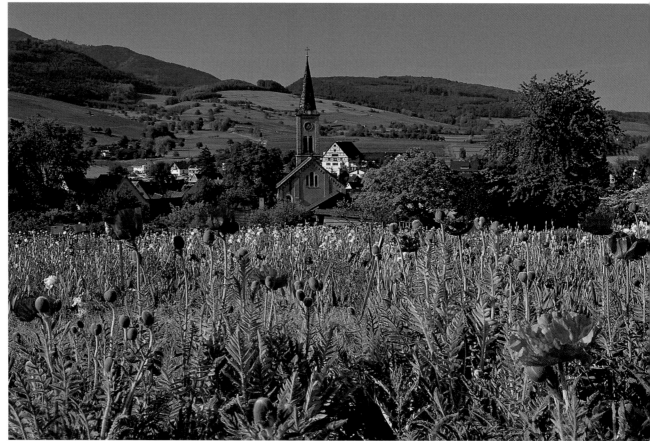

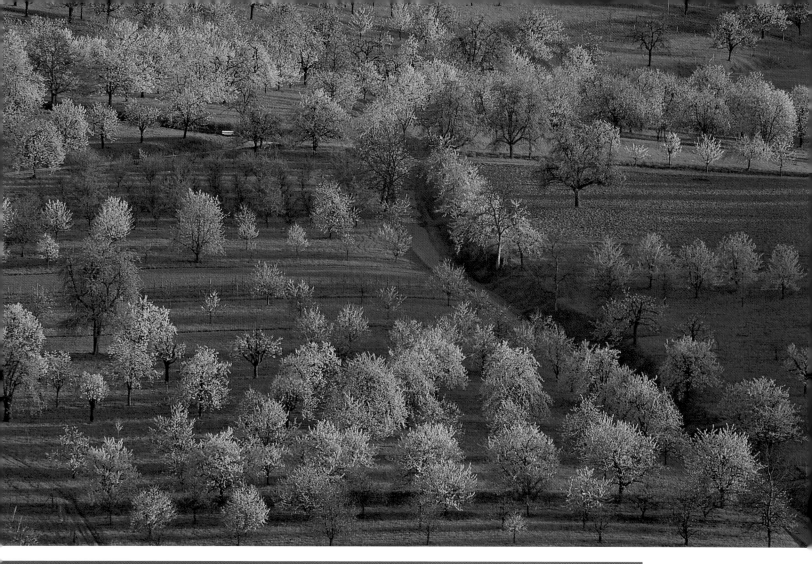

Above:
Fields of blossom in the cherry orchards of Obereggenen brighten the countryside in spring, bearing promise of delicious dark red summer fruit.

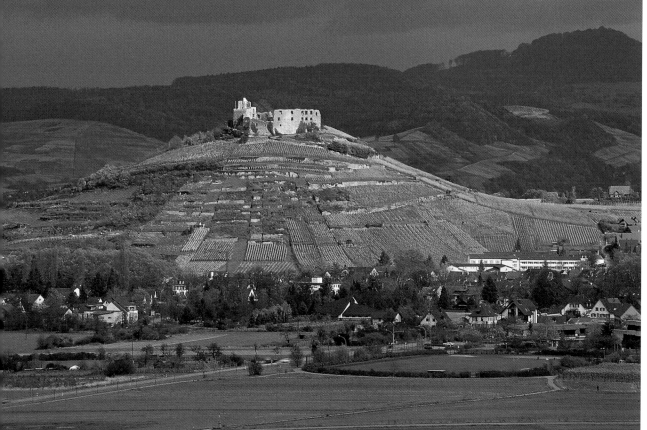

Left:
The most famous inhabitant of Staufen was alchemist and magician Johann Georg Faust, the protagonist of Goethe's best-known work who paid the ultimate price in his quest for knowledge. Local lord Anton of Staufen is said to have hired Faust to make gold. Faust himself died in the Löwen inn in 1539 in what is thought to have been a chemical explosion.

Below:
The present parish church of St Trudpert with its grand onion dome goes back to 1715. Much of the baroque complex built by Austrian architect Peter Thumb has been preserved. The site itself is much older, dating back to c. 640 when Irish monk St Trudpert came to the Münster Valley to convert the Alemanni to Christianity.

Top right:
St Ulrich on the western slopes of Schauinsland Mountain. St Ulrich founded a Benedictine monastery here in 1087 which was taken over by the abbey of St Peter's in 1560. The present monastic church was erected by Peter Thumb between 1739 and 1742.

Centre right
The festival of St Trudpert is held on the last Sunday in April when a priceles

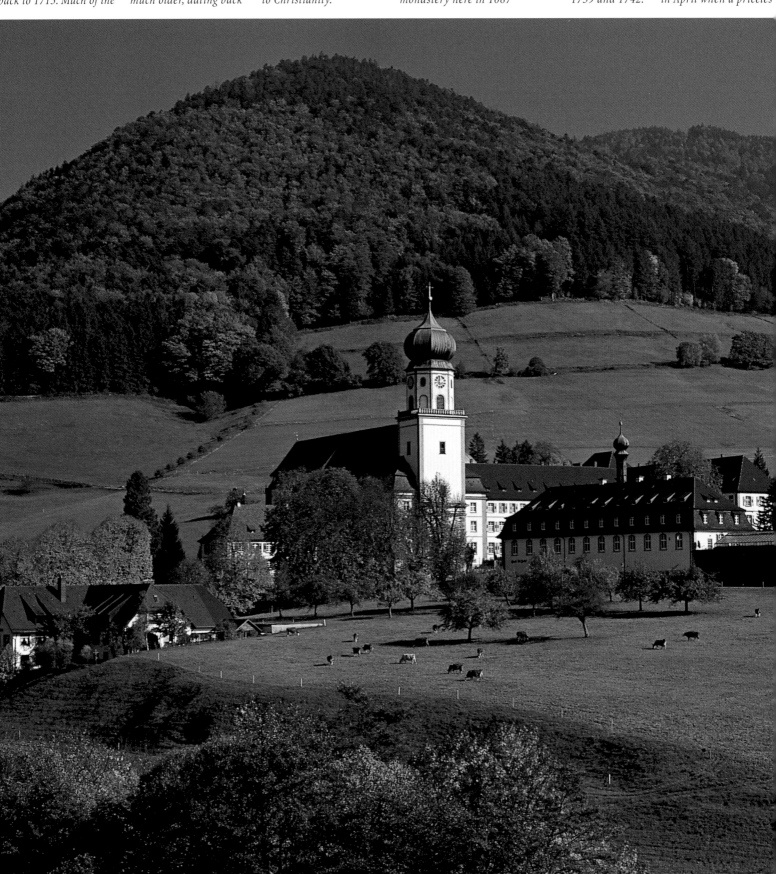

Bottom right:

The church of St Cyriak is one thousand years old. The former monastery church in Sulzburg is one of the cultural treasures of the Markgräfler Land. The steeple was constructed during the 11th century; recent research has shown that some of its beams are from a tree which was felled in the winter of 996.

Romanesque cross from c. 1175 is ceremoniously paraded through the village.

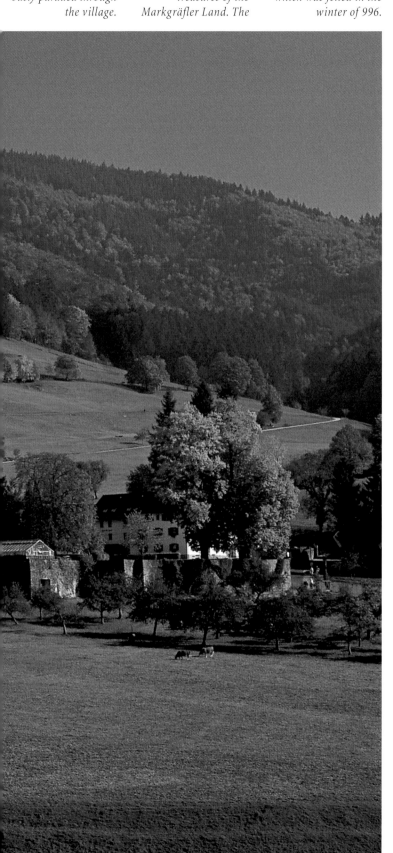

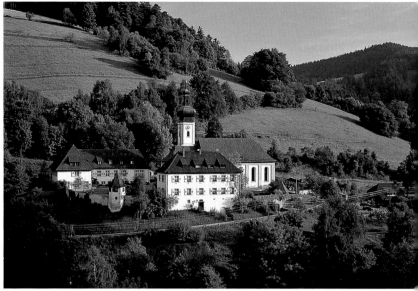

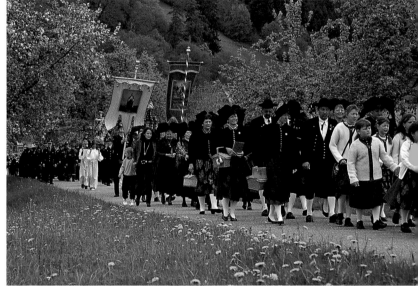

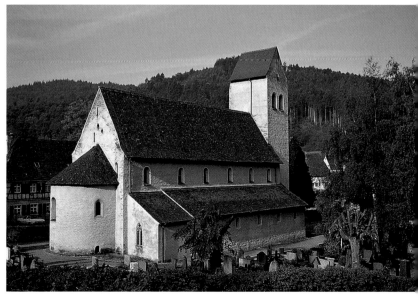

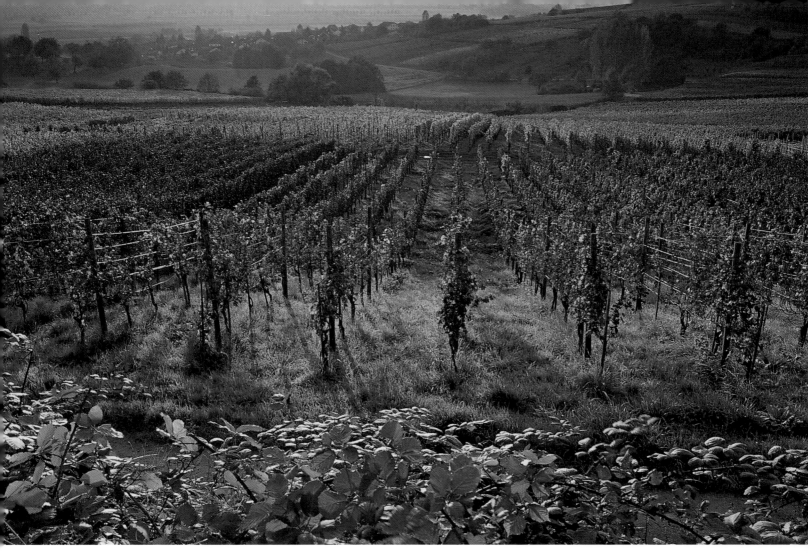

Above:
Gutedel grapes thrive on the slopes of Fischingen in the picturesque Markgräfler Land, the area south of Freiburg between the floodplains of the Rhine and the foothills of the Black Forest.

Right:
Wild tulips in bloom in the rolling hills of the Markgräfler Land, here near Weil.

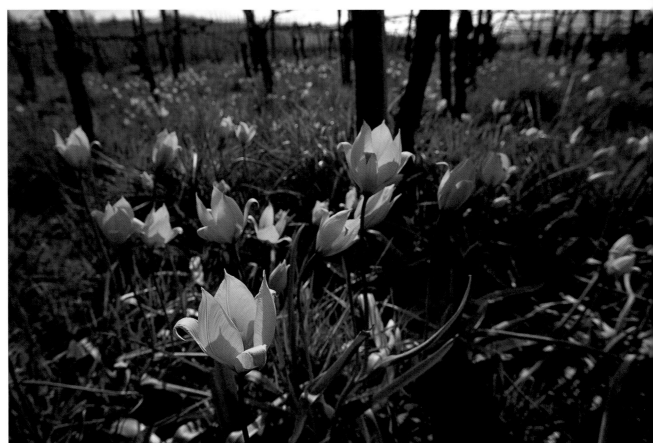

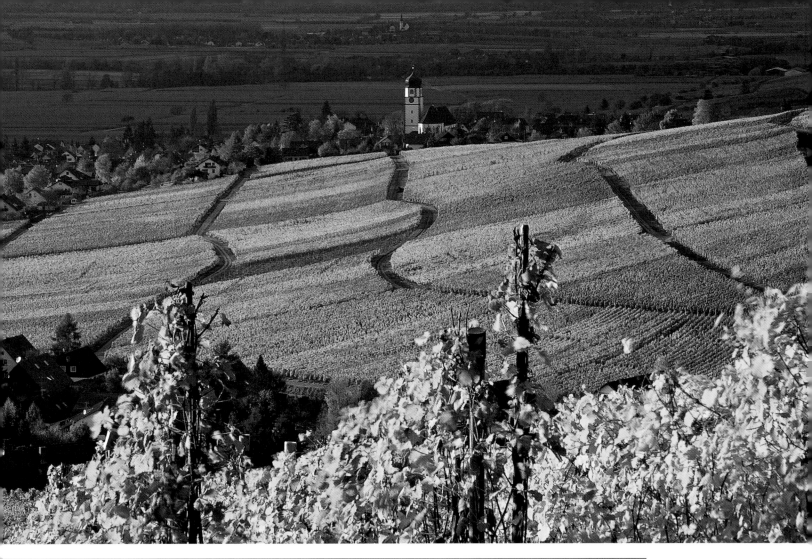

Above:
Not far from Ehrenkirchen in the Markgräfler Land. The southwesternmost tip of the Black Forest borders on France and Switzerland. The loess soil and mild climate are ideal for the cultivation of grapes for winemaking.

Left:
Outside the wine village of Britzingen in the Markgräfler Land between Freiburg and Basle. Excellent Badensian wines are made here, much to the delight of visitors to the nearby spas of Badenweiler, Bad Bellingen and Bad Krozingen.

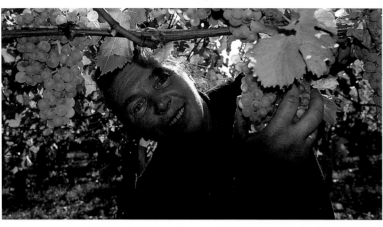

Wine harvest in the Markgräfler Land, home of the Gutedel grape. Margrave Karl Friedrich of Baden – later the grand duke of Baden – introduced this type of grape to the area from Vevey on Lake Geneva in Switzerland. It has been grown here since 1870 and makes up 40 % of the overall yield. The Gutedel or Chasselas is thus also often known as the Markgräfler grape. The wines it produces have a delicate bouquet, are simple and pleasant in character and have a mild but stimulating acidity. Usually made into a dry wine, the Gutedel is easily digestible.

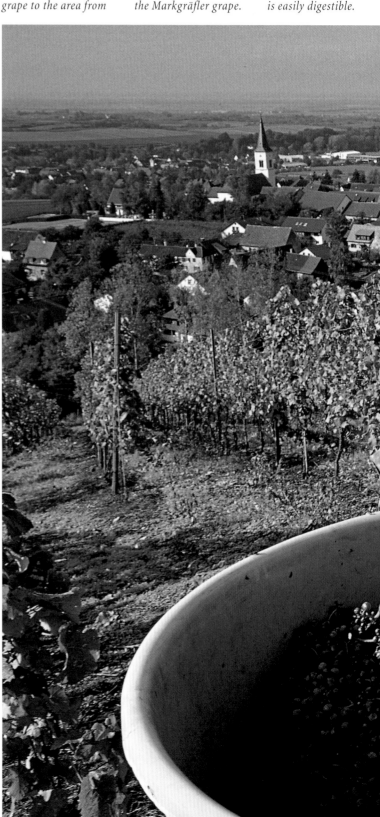

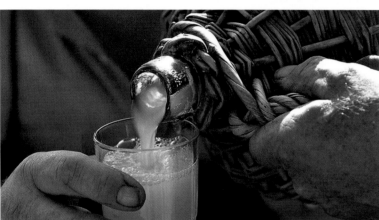

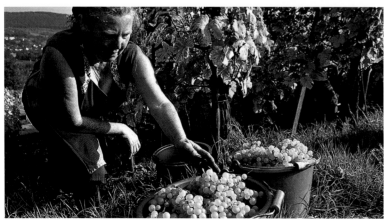

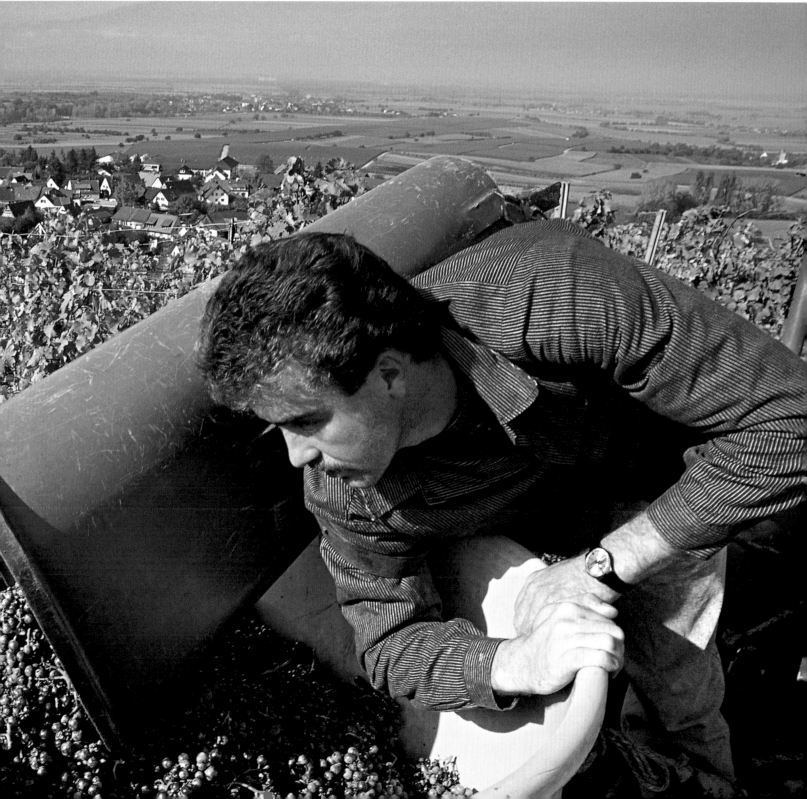

Below:
Oelberg near Ehrenstetten.
The vineyards here have
remained unchanged for
centuries, turning fan-
tastic colours each year
in autumn.

Top right:
The wine village of
Schliengen is in the
warmest wine-growing
region in Germany.

The parish church at its
centre dates back in
part to the Romanesque
period.

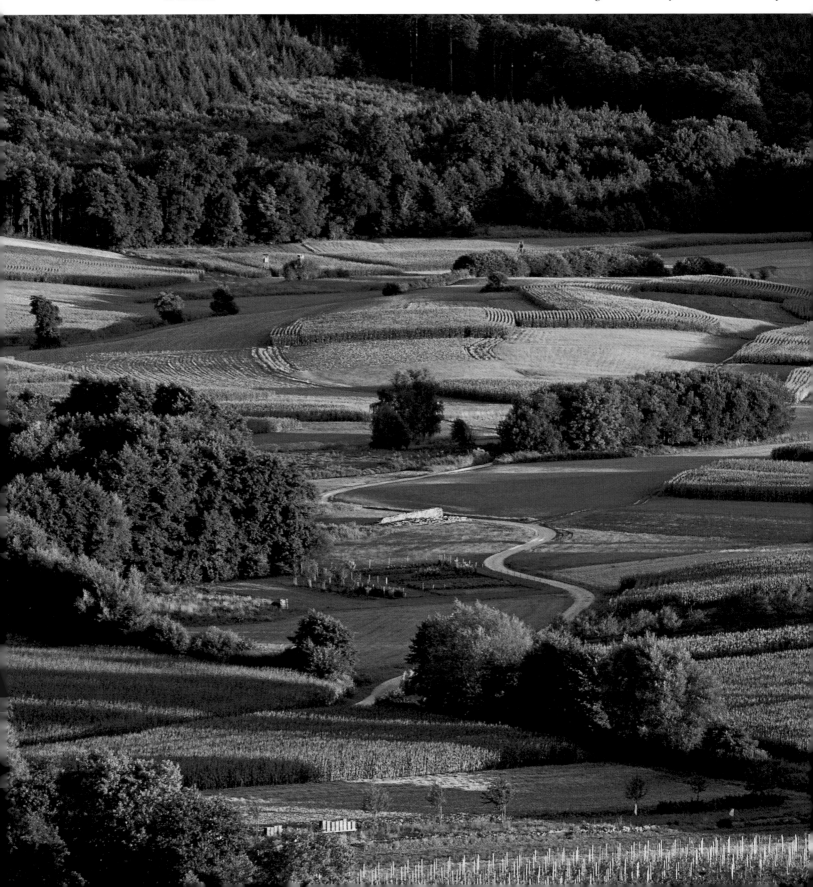

Centre right:
A crucifix in the Oelberg vineyards near Ehrenstetten. The Oelberg is an amalgamation of three

smaller vineyards which were merged in the wake of the Europian Wine Law of 1971.

Bottom right:
The wine village of Kirchhofen with its baroque pilgrimage church dedicated to the Virgin Mary lies between Kirchberg and Höllhagen.

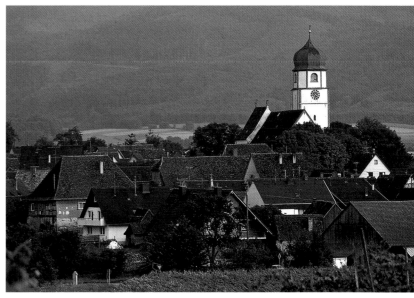

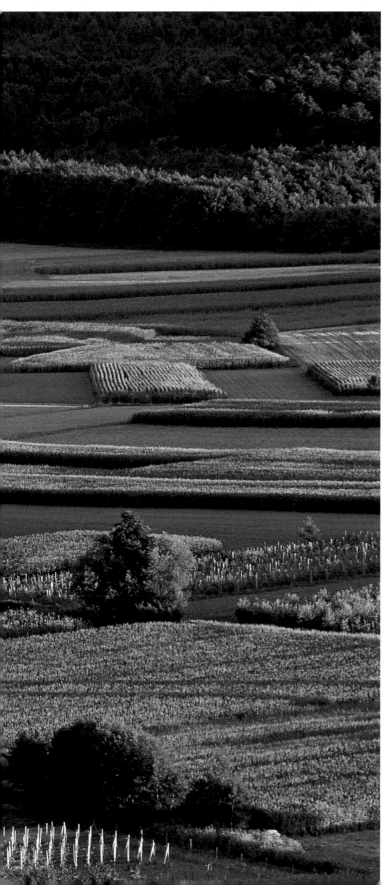

The little town of Mahlberg. The castle was an imperial fief visited by Staufer Emperor Frederick II in 1218. In 1630 the margrave of Baden built a baroque palace here, now the town's local landmark.

Tennenbach Monastery in the Breisgau, of which only the tiny chapel remains. Founded in 1161, the old Cistercian monastery had a turbulent history. During the Peasant War the entire complex was razed to the ground, leaving only the chapel intact; it was again destroyed in 1723 and dissolved in 1806. In 1829 the monastery church was dismantled and re-erected in Freiburg where it was bombed during the Second World War.

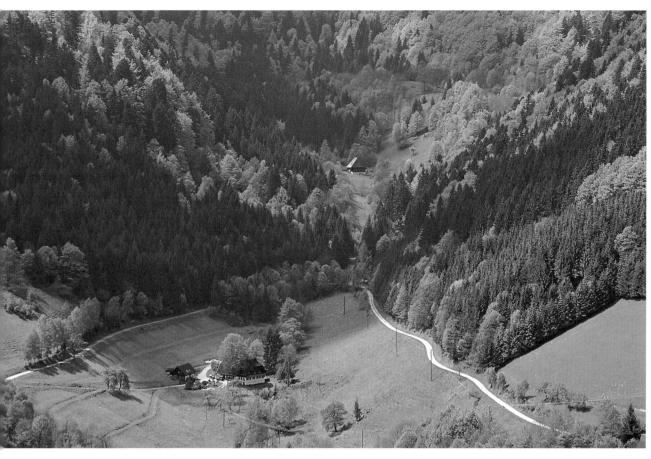

View of the pastoral Simonswälder Valley through which the Wildgutach River flows. The valley is probably named after an early Alemannic settler bearing the name "Sigmanswald".

Many of Kenzingen's beautiful houses date back to the 17th and 18th centuries. The nearby sunny slopes are ideal for the cultivation of excellent wines.

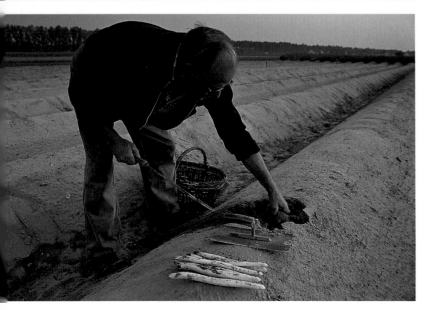

Top and centre left:
The rural Ortenau is famed for its fresh produce, with many of the local farmers selling direct to their customers. Fruit and vegetables are harvested just a few hours before they are needed; this horseradish (top) and crisp green vegetables are sure to find a buyer at the local market.

Bottom left:
Up early to harvest plump stalks of white asparagus – the most popular type in Germany – for the farmers' market in Freiburg.

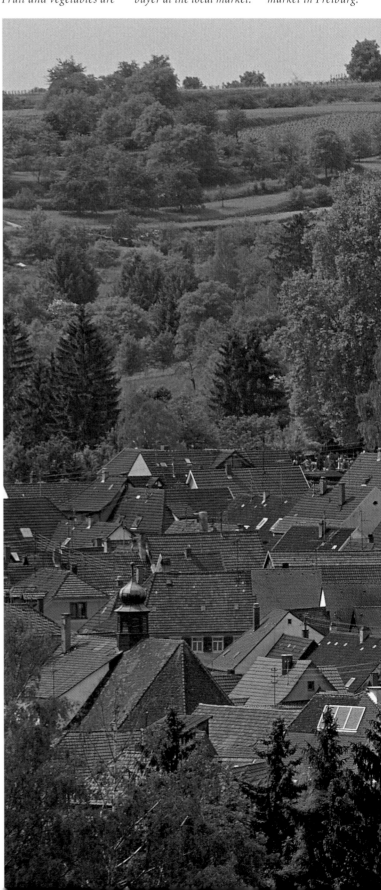

94

Below:
With its magnificent parish church and intact historic centre, now a protected heritage site, Ettenheim bei Lahr is well worth a visit. Half-timbered dwellings and mini baroque mansions prettily adorn the narrow streets.

PINE FOREST, THERMAL SPRINGS AND THEME ROUTES

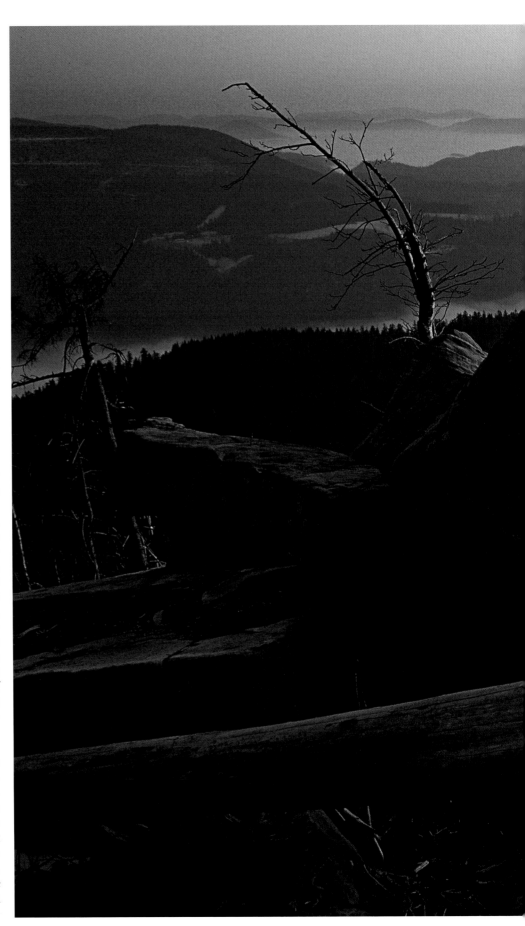

From the top of the Hornisgrinde (1,164 metres/3,819 feet), the highest mountain in the Northern Black Forest, you can see out over the Rhine plateau as far as Strasbourg; on a good day you can even spot the Alps in the distance. In the cold winter months inverted weather conditions often bless the summit with sun while the surrounding valleys are hidden in thick fog.

The breathtaking scenery of the Northern Black Forest is the stuff dreams are made of – particularly in the winter. With the deep valleys shrouded in mist, the peaks of the surrounding mountains are often bathed in glorious sunshine. On days like this there are magnificent views out across the floodplains of the River Rhine to the distant undulations of the Vosges, especially from the 1,164 metres (3,819 feet) of the Hornisgrinde, the highest elevation in the area. Picturesque lake basins, such as the legendary Mummelsee, glitter between the trees.

The countryside of the north is an eldorado for hikers. Motorists can also enjoy the scenery along one of the many theme tourist routes in the area. The Schwarzwald-Hochstraße (Black Forest Highlands Route), for example, runs from the thermal springs and casino of Baden-Baden across a spectacular ridge to Freudenstadt, the city with the largest market place in Germany. The Schwarzwälder Bäderstraße (Black Forest Spa Route) joins Freudenstadt and Pforzheim, the River Nagold and Baden's vineyards, taking in various health resorts, art and culture along the way. The Schwarzwald Tälerstraße (Black Forest Valley Route) goes from Rastatt to the former Benedictine monastery of Alpirsbach. For connoisseurs of asparagus, the Badische Spargelstraße (Badensian Asparagus Route) is a must in early summer.

One of the most beautiful valleys of the Black Forest is Glottertal where one of Germany's popular soaps is filmed. The Gutachtal is where the famous red pom-pom hats come from; Triberg boasts Germany's highest waterfall. Time should be taken to visit the clock museum in Furtwangen – and to savour the cuisine and excellent wines of Baden. There's plenty of opportunity to do so; the Northern Black Forest has an unusually high number of acclaimed gourmet restaurants.

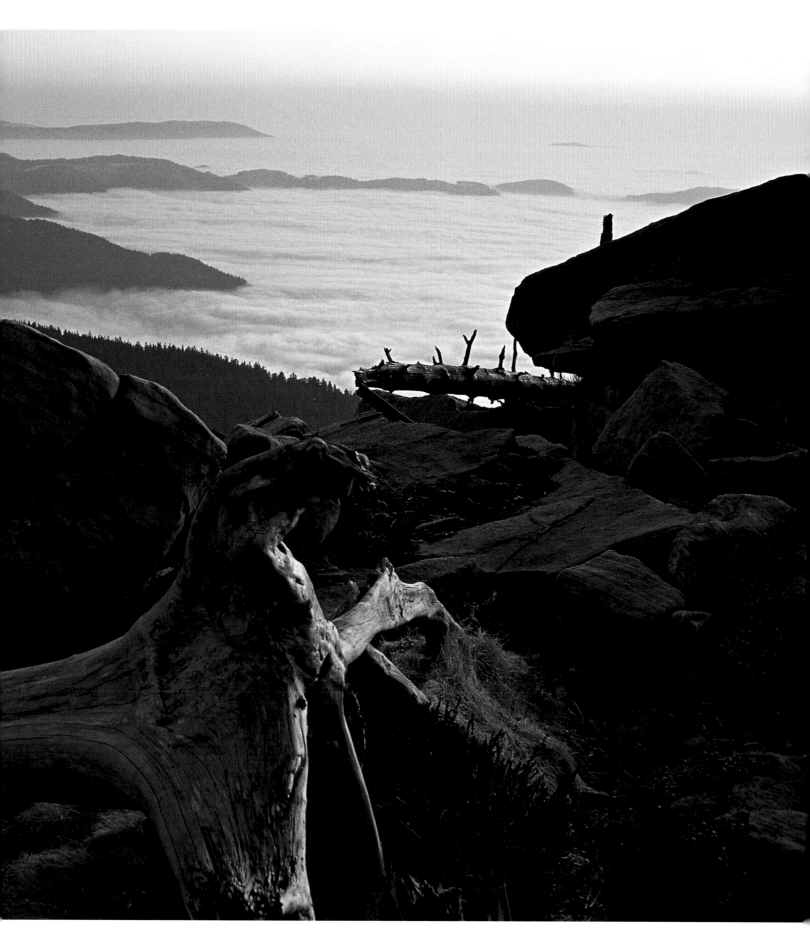

Below:
The Mummelsee is the highest-lying and largest of the eight lake basins in the Black Forest, created by glacial movement at the end of the Ice Age 10,000 years ago. The lake is shrouded in legend; this is where water nymphs play under the watchful eyes of a lake god.

Top right:
The Schliffkopf is one of the areas most heavily damaged by the hurricanes of 1999. The forest is, however, slowly recovering; new growth is springing up amongst the fallen trees

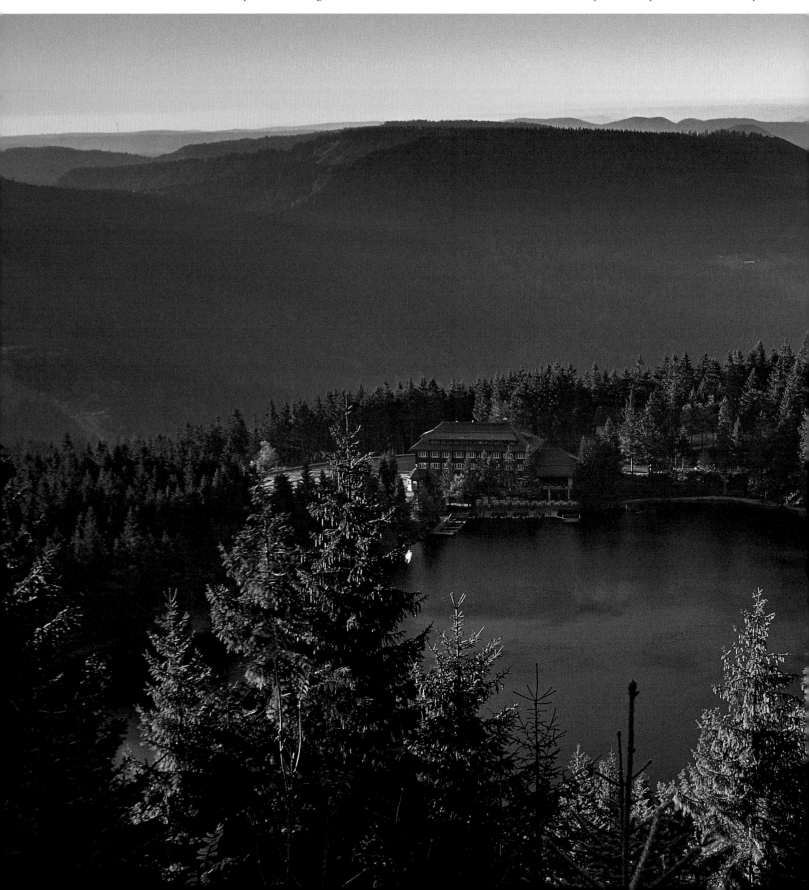

Centre right:
mpenetrable, dark green fir forest is the trade-mark of the Black Forest. With long taproots fir is able to withstand heavy storms, whereas the spruce with its flat root system is easily uprooted.

Bottom right:
The closed "fir cones" children like to collect in the forest in fact come from the spruce. Fir cones drop seed while still on the tree; only the empty cones fall to the ground.

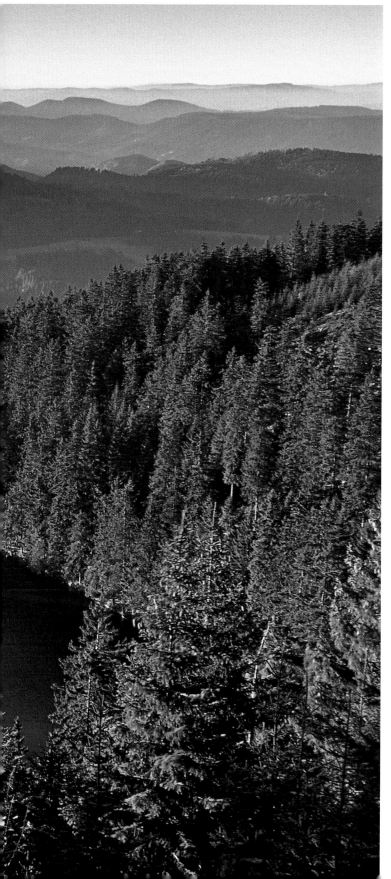

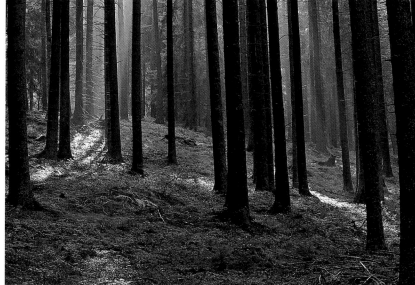

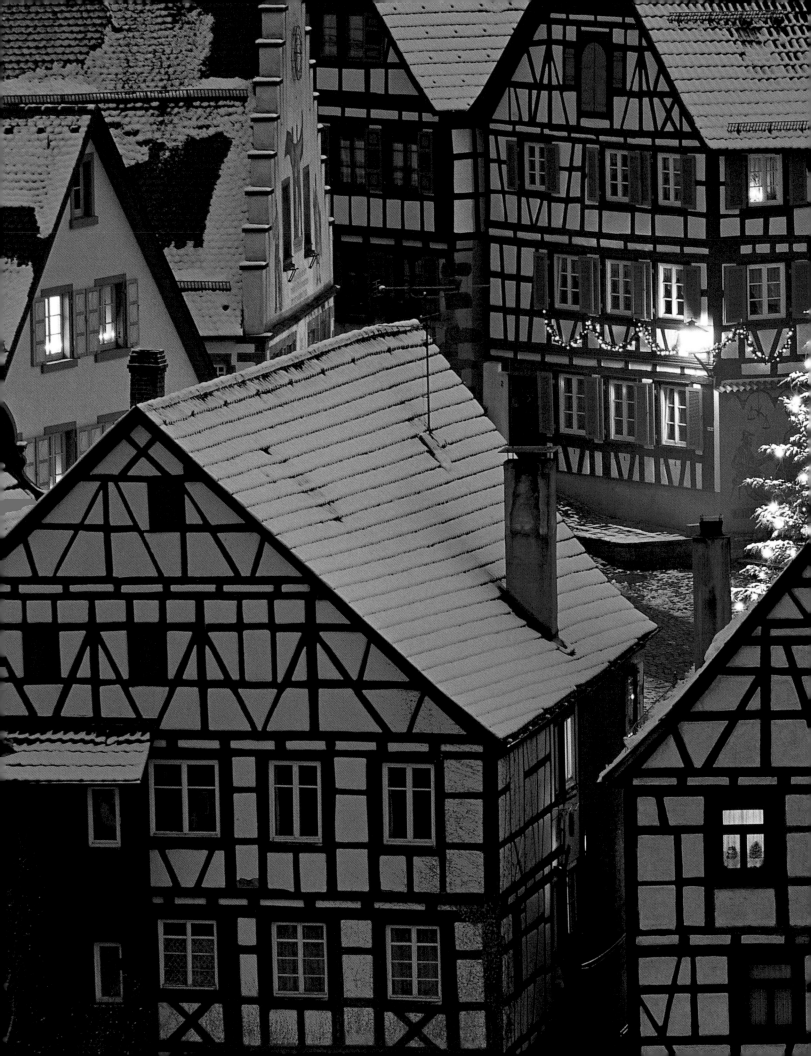

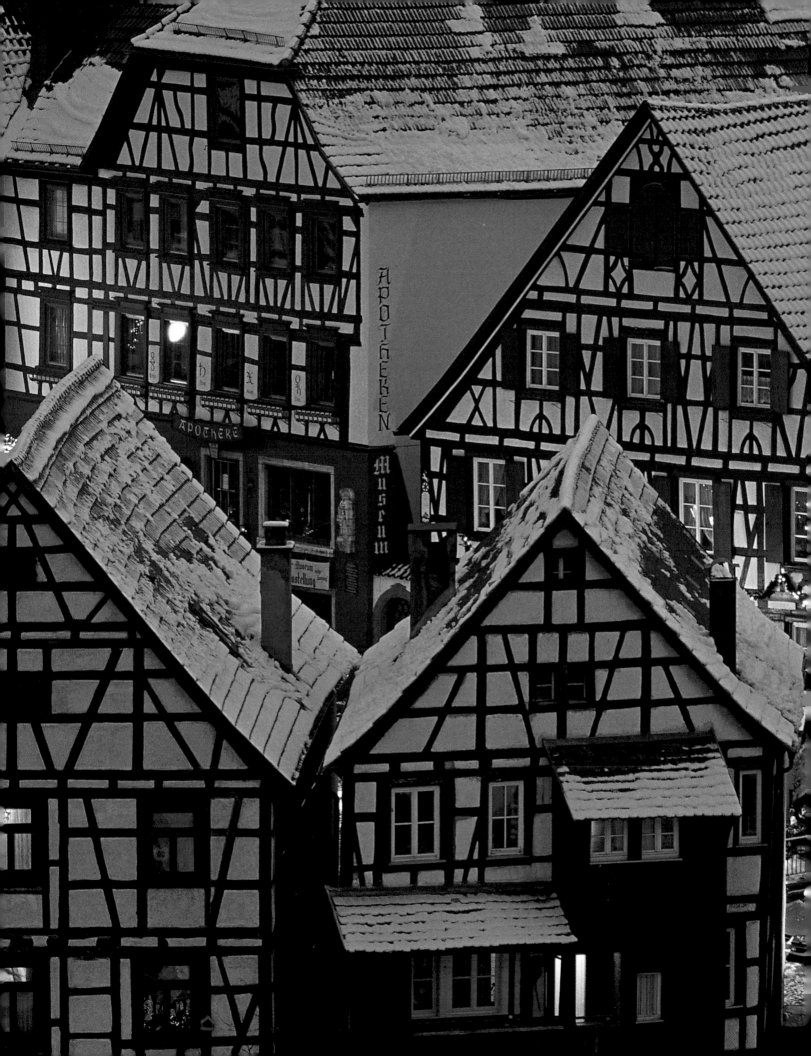

Page 100/101:
The market place in Schiltach, rebuilt after the last great fire of 1791. With a thin covering of snow dusting the roofs, the half-timbering and Christmas lights make it look like something out of a fairy tale.

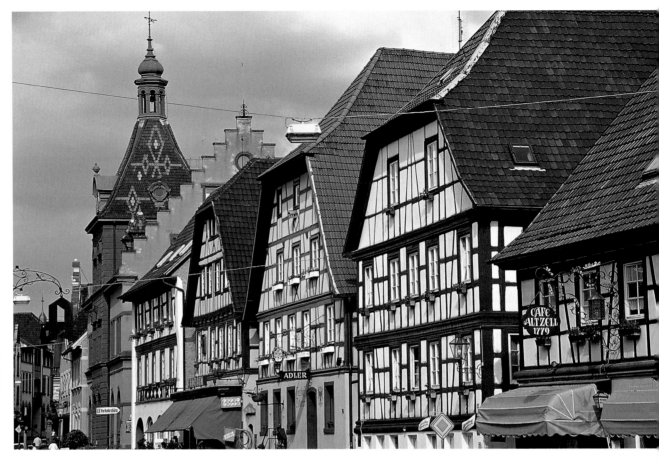

Zell am Harmersbach, founded by the monastery in Gengenbach, also has a collection of wonderful half-timbered houses. The town was first mentioned in documents as "Cella" in 1139.

The knight of Gengenbach atop the market fountain proudly represents the town's period of self-rule under the emperor. He holds a scroll listing the town's privileges in his right hand and the Gengenbach coat of arms in his left.

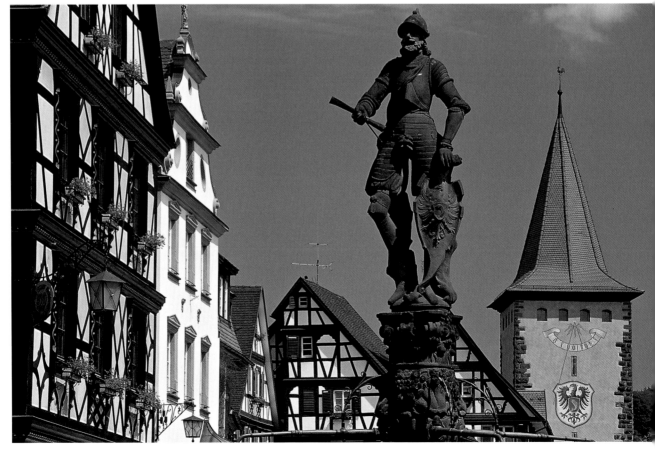

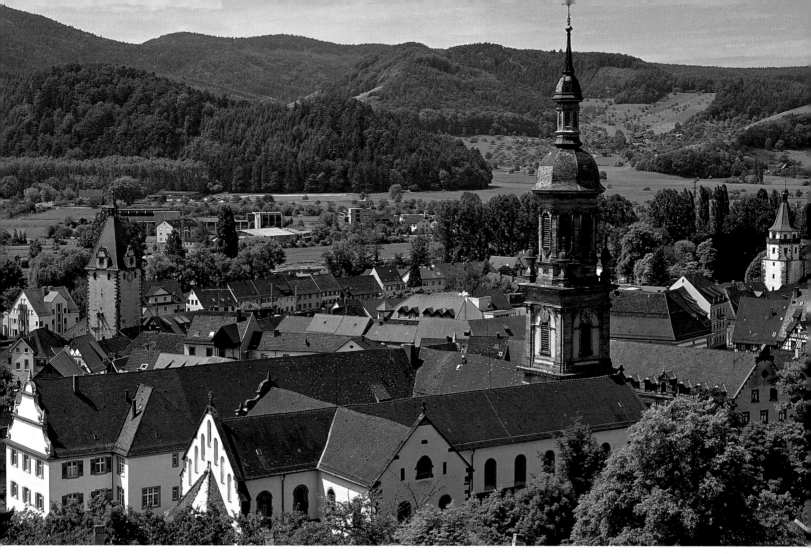

Above:
Under the Frankish duke Ruthard a bishop from Reichenau Monastery founded the Benedictine monastery of Gengenbach in 725. In 1360 the little town which had sprung up around it was made a free city of the Holy Roman Empire. The town evolved in its present form from the late 17th century onwards after having been destroyed during the Palatinate War of Succession in 1689.

Left:
Zell am Harmersbach was once the smallest free city in the Holy Roman Empire. The main street running through its centre is a juxtaposition of half-timbering and Art Nouveau.

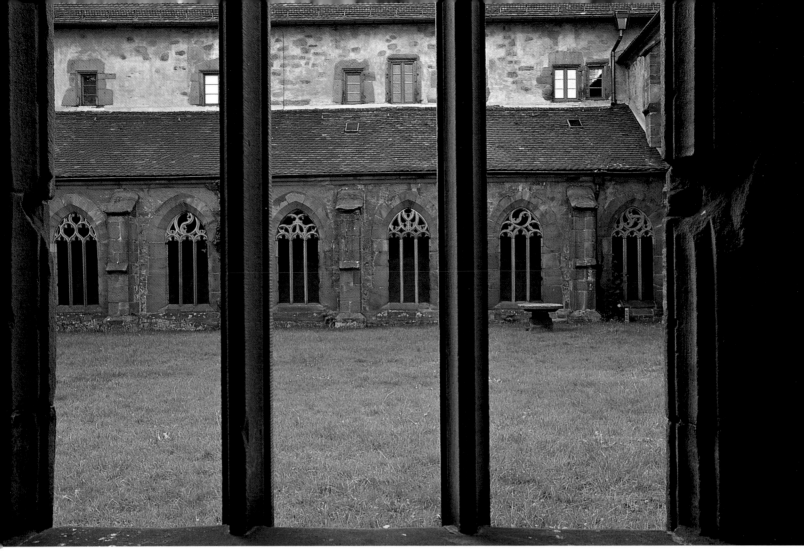

Above:
Kloster Alpirsbach was
once one of the reformist
monasteries of the
German southwest.
It was founded in 1095
by the three counts
Adalbert of Zollern,
Rutmann of Hausen and
Alwig of Sulz. Its clois-
ters are from the late
Gothic period.

Right:
The Romanesque church
of what was Alpirsbach
Monastery, an aisled,
columned basilica built
in the shape of a cross, is
now a Protestant parish
church.

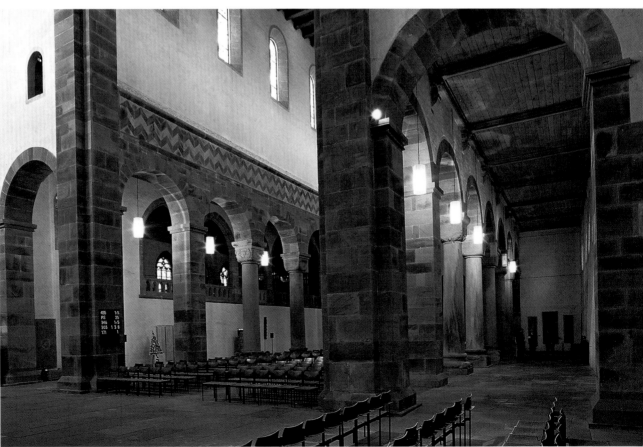

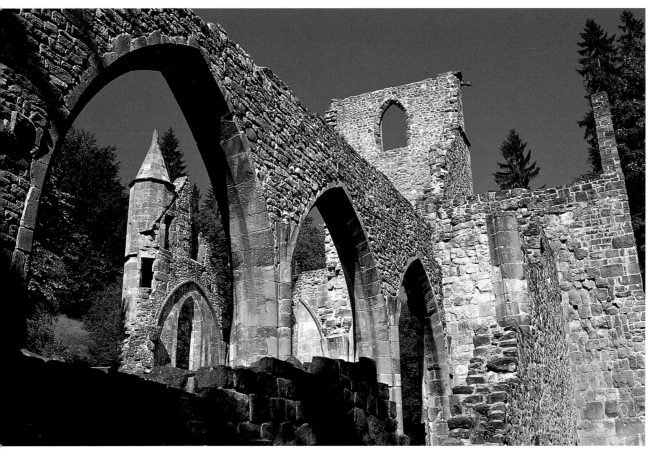

Left:
The ruined monastery of Allerheiligen or All Soul's was established in c. 1196. Ruled by a Premonstratensian provost, it was a regional centre of culture for over 600 years. It fell into its present state of decay soon after its dissolution in the 19th century.

Below:
Allerheiligen. The ruins of what was once a powerful monastic centre lie almost hidden by tall fir trees in the valley of the Lierbach.

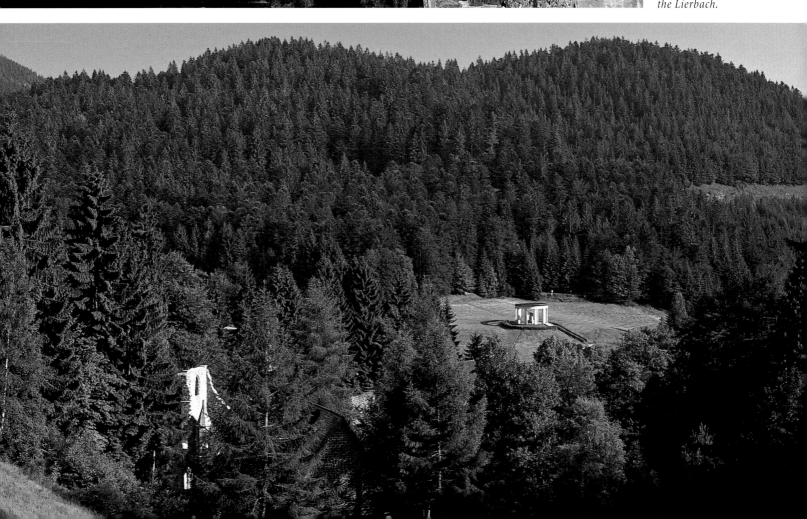

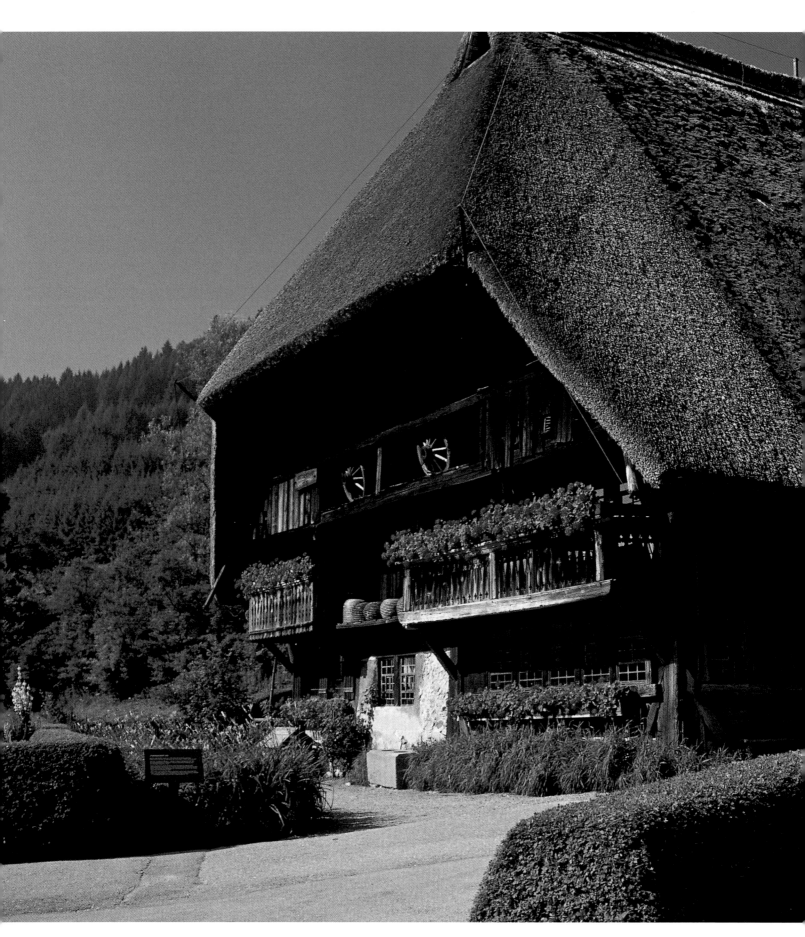

Thatched roofs have become very rare. This one is at the Vogtsbauernhof Open-Air Museum in Gutach which also has many other typical Black Forest farmhouses from the 16th and 17th centuries.

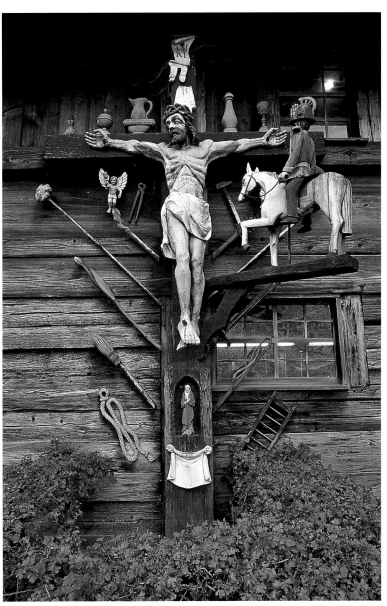

Above:
A Longinus crucifix on the walls of the Hippenseppenhof barn at the Vogtsbauernhof Open-Air Museum. The Roman centurion St Longinus, who stuck his spear into Christ's side, is depicted wearing an 18th-century uniform.

FROM THE BLACK FOREST TO CHINA –

It must have been the end of the 17th century when a Black Forest glass merchant brought a wooden clock back home with him from his travels to Bohemia. His souvenir was to herald the dawning of a new age for farmers eking out a lowly existence on their isolated farmsteads. They had always told the time by the sun and the moon; this new mechanism was now able to divide up the day more accurately into quarter hours. The wooden cogs weren't precise enough to display minutes, let alone seconds, but this was soon to change. During the long winter months the locals carved and filed away at the mechanism, producing timekeeping masterpieces which visitors and collectors can still admire today at the clock museum in

Furtwangen. Necessity had given rise to a roaring success. In the Black Forest it was traditionally the youngest son who inherited the farm as he was expected to live the longest and thus be able to care for his ageing parents. Elder siblings were left to make their own way in the world; the advent of the clock provided them with a welcome source of income, saving the region from abject poverty.

New branches of production were soon established, one of which was the painting of dial plates. The grand 24-hour clock with its lacquered wooden clock face and striking trains was the number one export from the Black Forest. Areas of trade expanded; clock bearers transported whole collections of timepieces on special wooden contraptions to the Hanseatic ports of the north, to Holland and to France. From here their goods were shipped all over the world, with clocks from the Black Forest keeping time in St Petersburg and even at the court of the emperor in China.

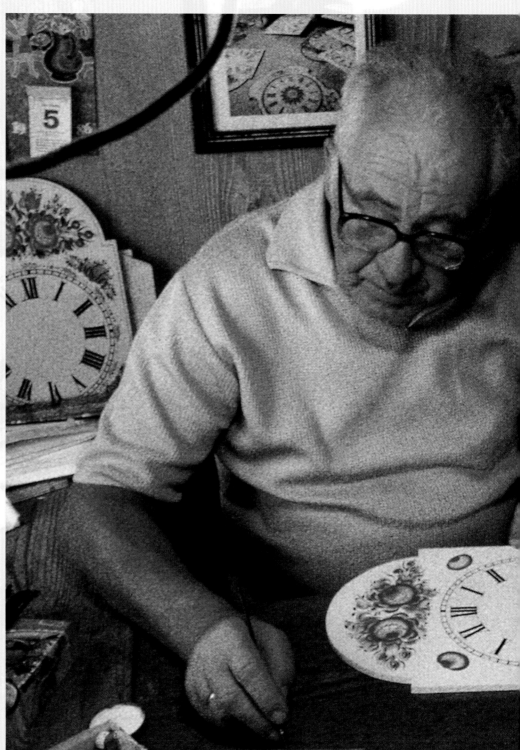

Left:
With over 9,000 exhibits, the clock museum in Furtwangen has the largest collection of timepieces in the whole of Germany..

Above:
No longer a common occupation: painting clock dials in Linach.

Small photos right, from top to bottom:
The German Clock Museum is jam packed with rarities and collector's pieces ranging from the first wooden clock mechanisms to the popular cuckoo clock to the atomic timekeeper.

These traditional cock and hen mugs being painted by hand in Zel am Harmersbach are to fresh German coffee what fine bone china is to English breakfast tea.

CUCKOO CLOCKS AND GLASSBLOWING

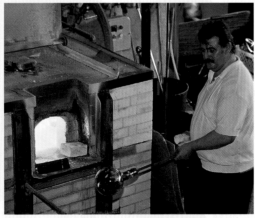

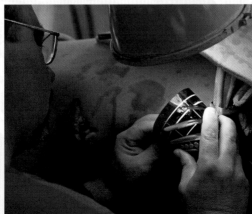

At exactly 1,450°C this mixture of quartz sand, potash and read lead turns into liquid glass.

This is then carefully processed to produce a work of art.

With their products crafted to mechanical perfection, clockmakers now concentrated on the appearance of their clocks, chimes and pendulums which ranged from a simple stone to cast metal weights shaped like fir cones, from the loud ringing of church bells to a soft melodic "cuckoo", from ornate clock faces to the typical railway cottage of the archetype Black Forest cuckoo clock. The railway building is modelled on the typical gatekeeper's cottages of the Badische Staatsbahn (Baden State Railway) from c. 1840. Originally a cock was supposed to crow the full hour. The tiny goatskin bellows attached to the organ pipes in the clock mechanism, however, were only able to manage a feeble "cuckoo" and so the cuckoo clock was born. The long winters gave the clockmakers of the Black Forest plenty of time to experiment. Imaginations ran riot, creating a magnificent array of timepieces, many of which featured elaborately carved wooden figures. There were clocks with people eating dumplings, clocks with lions who rolled their eyes and clocks where military sentries marked the passing of the hour. The masters of the trade had carefully assembled mechanisms, music boxes and moving figures to produce a ticking work of art.

Another Black Forest craft which is shrouded in legend is glassblowing. Tales were often told of a glass mountain full of secrets and the spirits of the afterlife which could only be opened by magic. One variation tells the story of a brave little girl who "cut off her little finger and stuck it into the side of the mountain", causing it to open and free her brother held captive inside. People learned how to melt glass in Central Europe in the High Middle Ages. The Black Forest, which at that time primarily consisted of deciduous trees, had everything the glassmaker needed: hornbeam for the manufacture of potash and to fire the ovens and streams running through areas of granite and red sandstone which provided quartz sand. The first glassworks set up operation in the 12th century. In the 19th century, however, the industry was struck by economic crisis. The advent of the railways meant that time was now of the essence; glassworks hidden deep in the forest were simply too far away from the new main lines for business to continue. Many families in the Black Forest were affected and forced into poverty. The forest itself, however, was given a chance to recover from the exploitation of its natural resources and through the planting of fast-growing spruce with little demand on its environment the area became the "black" forest we know and love today.

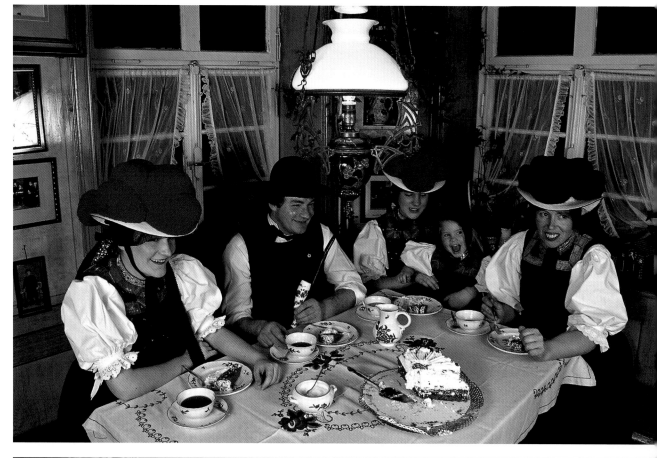

The traditional pom-pom hat and creamy kirsch and chocolate gateau have become synonymous with the Black Forest. Here, locals tuck into afternoon "Kaffee and Kuchen" after taking part in a parade.

The pom-pom hat spiralled to fame through the paintings of Wilhelm Hasemann and the operetta "Das Schwarzwaldmädel" by Berlin composer Leon Jessel, whose leading lady was never seen without it.

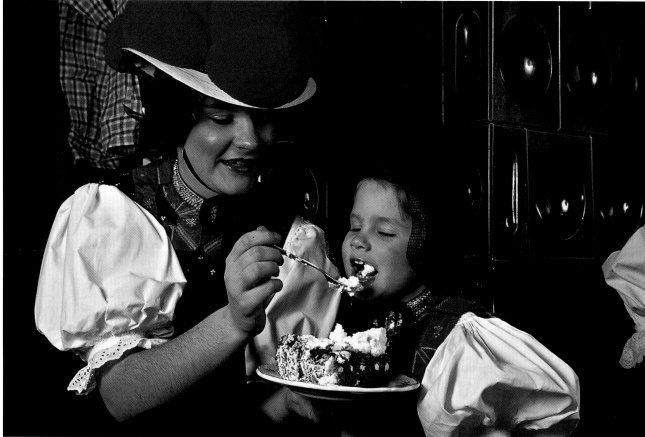

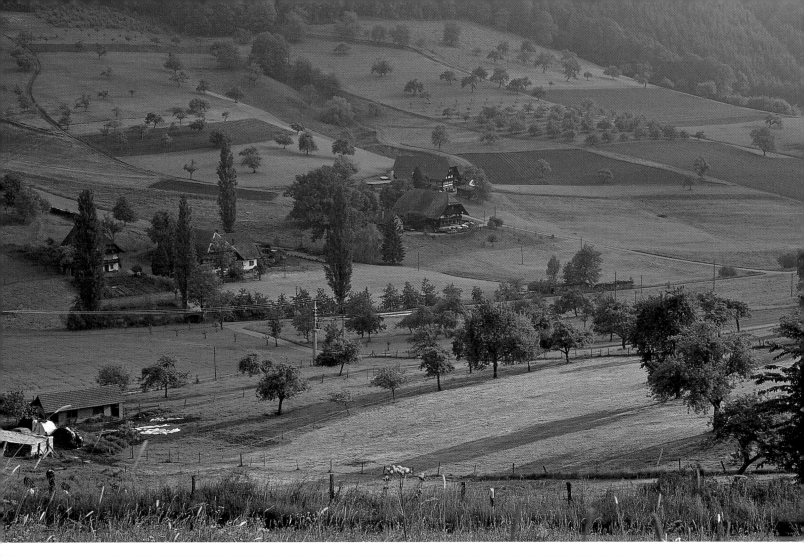

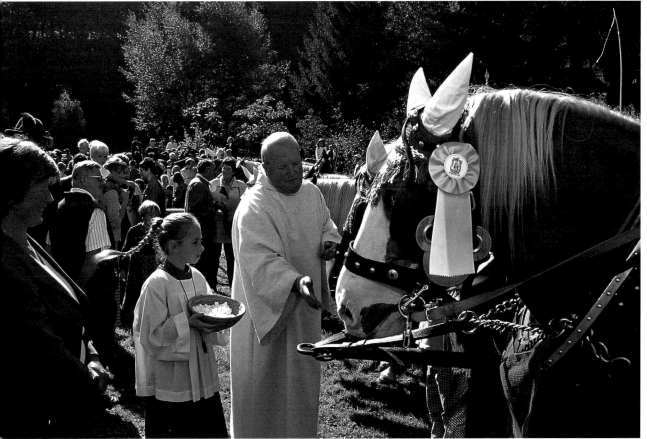

Below:
Wine-growers and co-operatives in the Badensian wine region also make sparkling wine or "Sekt" which is being tasted here at a cellar in Durbach.

Top right
This winery in Kappelrodeck produce individual wines with plenty of character

Careful maturation and low sulphur levels make these vintages particularly pleasant and digestible.

Centre right:
Durbach wine from the Markgräfler Land being tasted for maturity straight from the barrel.

Bottom right:
The Black Forest also has a number of registered home distilleries which make excellent bottles of schnapps and brandy.

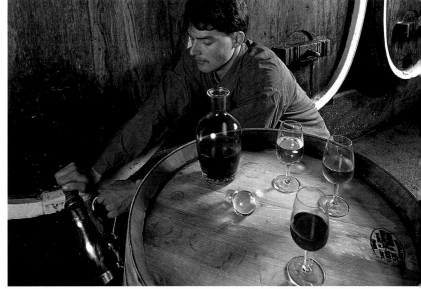

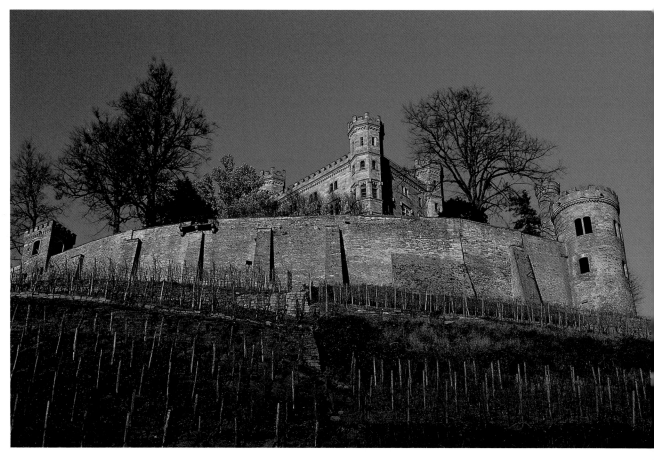

Visible for miles around, Schloss Ortenberg in the Ortenau proudly marks the entrance to the Kinzig Valley. The main buildings were built in the style of an English castle during the 19th century.

Viniculture dates back to the year 1391 in the town of Durbach. The Durbach Valley running from east to west between the Black Forest and the Vosges is a nature conservation area, its sunny south-facing slopes ideal for the cultivation of wine.

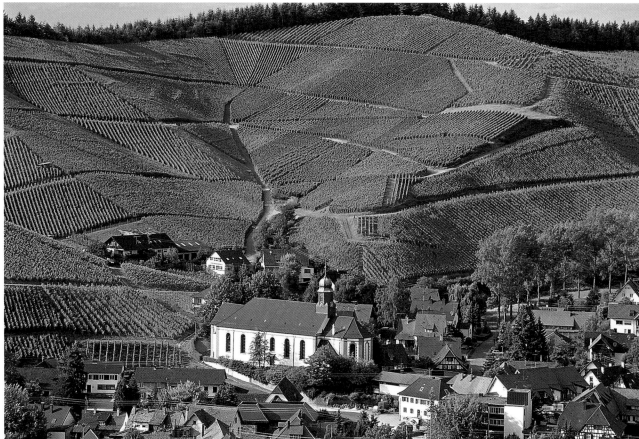

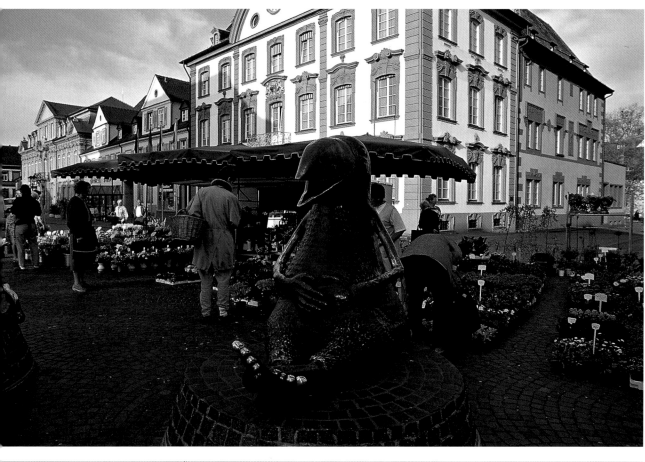

Offenburg is the gateway to the Black Forest. Founded by the Zähringen dynasty, the regional capital of the Ortenau is rich in baroque architecture.

The 19th-century neo-Renaissance castle of Rodeck towers above the pretty village of Kappelrodeck.

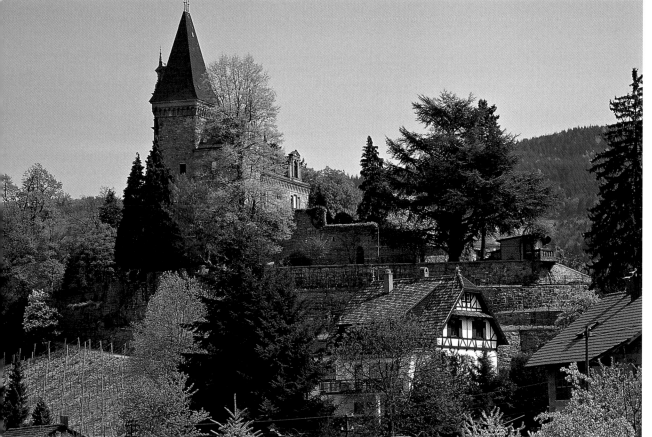

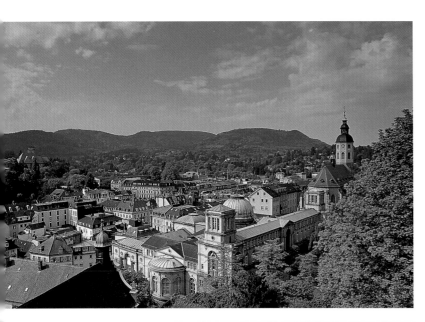

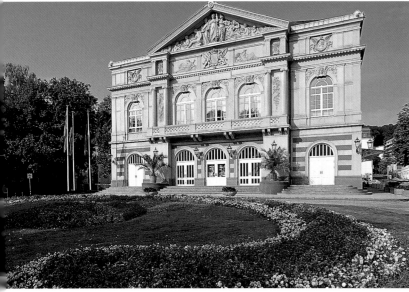

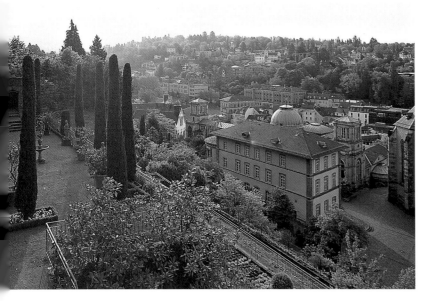

Top left:
View of the spa and
collegiate church at the
international health
resort of Baden-Baden.

Originally a Roman-
esque basilica, the
church is the oldest
building in the city and
its main parish church.

Centre left:
The theatre in Baden-
Baden was built with
money generously
"donated" by guests to
the local casino. Casino

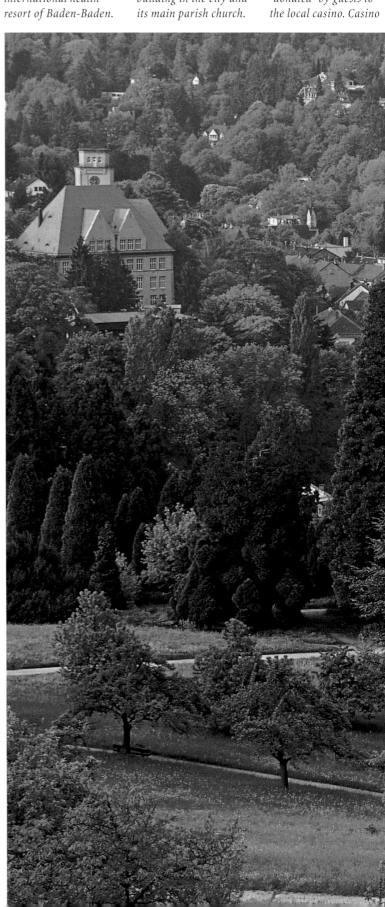

easeholder Edouard
Bénazet had it erected
between 1860 and 1862,
modelling it on the
famous opera house in
Paris.

Bottom left:
The old steam baths are
now the headquarters of
Baden-Baden's art soci-

ety. They were once heated
by the hot underground
springs which have made
the town so popular.

Below:
Hugging the shores of
the River Oos, Baden-
Baden is dominated by
the twin sandstone
spires of the neo-Gothic
Protestant church.

The town positively
boomed during the mid
19th century, enjoying
cult status amongst the
established aristocracy
and the nouveau riche.

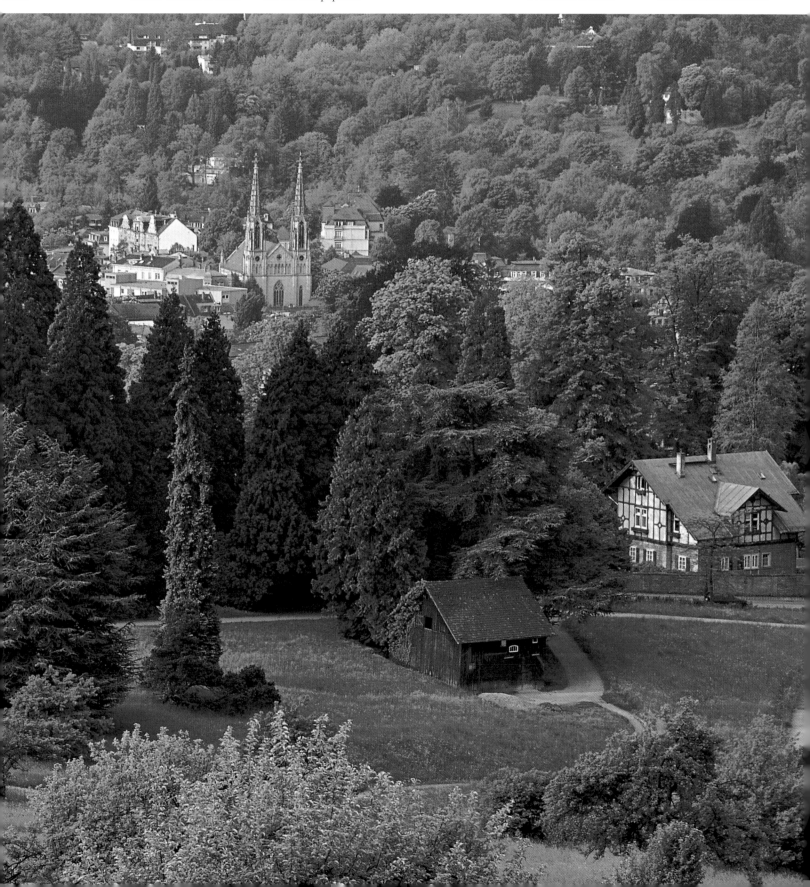

Above:
The vineyards of
Neuweier just outside
Baden-Baden. The castle
of Neuweier perched
high up on the slopes
makes first-class white
Riesling wine.

Right:
The high moors near
the lakes of Hohlohsee
and Wildsee in the
Northern Black Forest
are unique to the area,
wild, isolated and
eerily primeval.

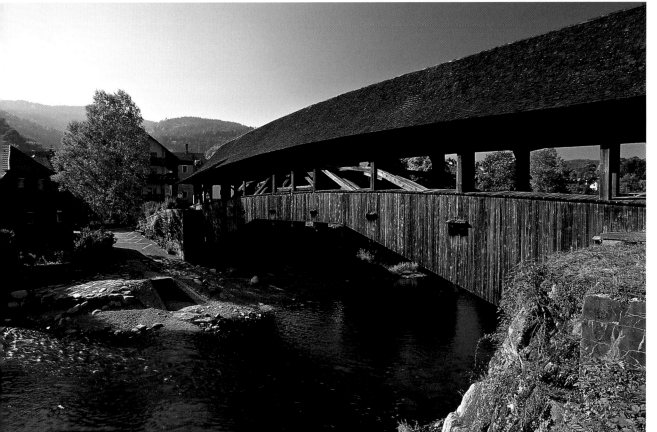

The valley of the Murg, the second-longest river in the Northern Black Forest, near Bermersbach. The Upper Murg Valley was inhabited by settlers from the nearby monastery of Hirsau during the 11th century.

Left:
The wooden cantilever bridge across the River Murg in Forbach was constructed in 1778. The Badensian boatmen working the Murg owned much of the forest around Forbach.

119

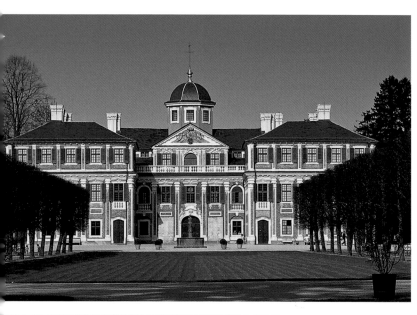

Schloss Favourite was built as a summer residence between 1710 and 1714 for Margravine Sibylla Augusta by Bohemian architect ML Rohrer.

Centre left:
The medieval castle of Berneck northeast of Altensteig lies high up above the valley of the River Nagold.

Bottom left:
The ruined Benedictine convent of Frauenalb was founded in 1185. In the centuries that followed it was destroyed and rebuilt

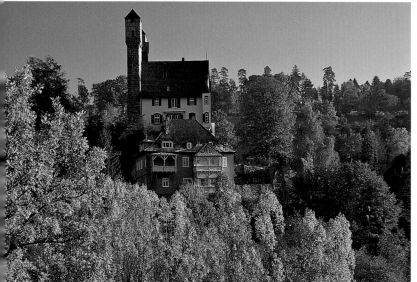

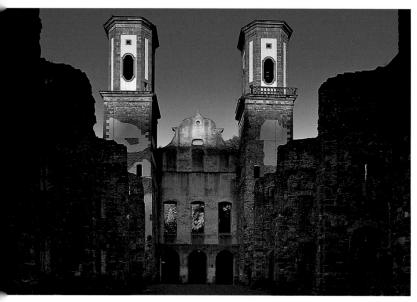

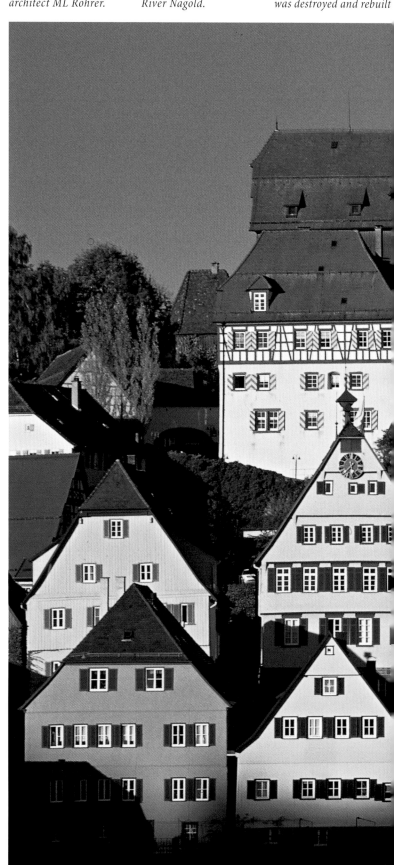

120

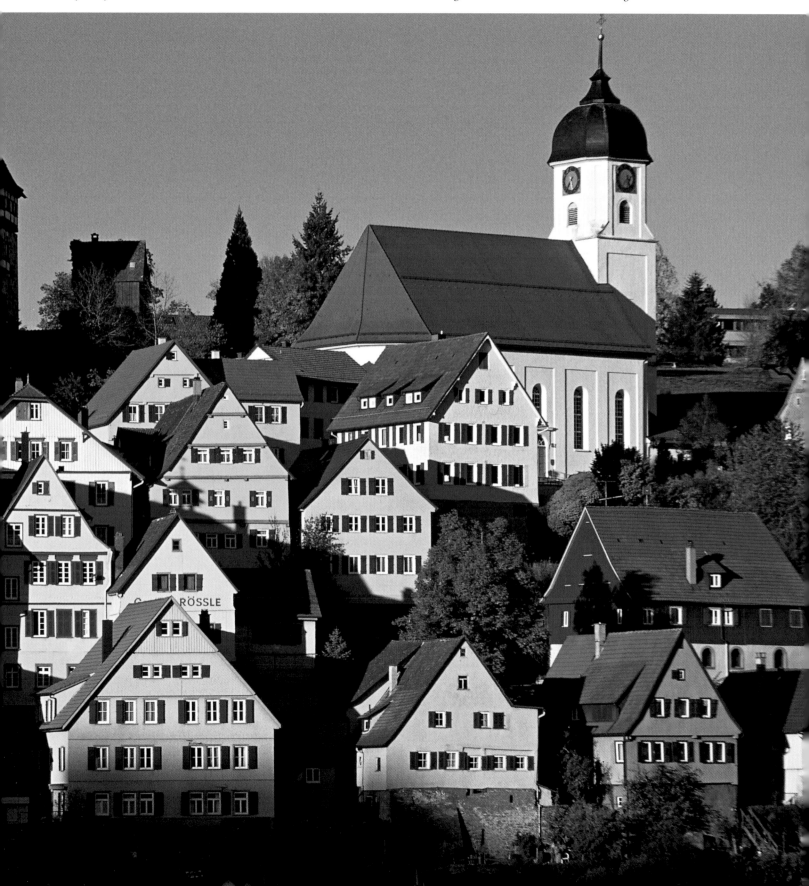

everal times. After the dissolution of the monaseries in the 19th century t first served as a hospital and then a factory.

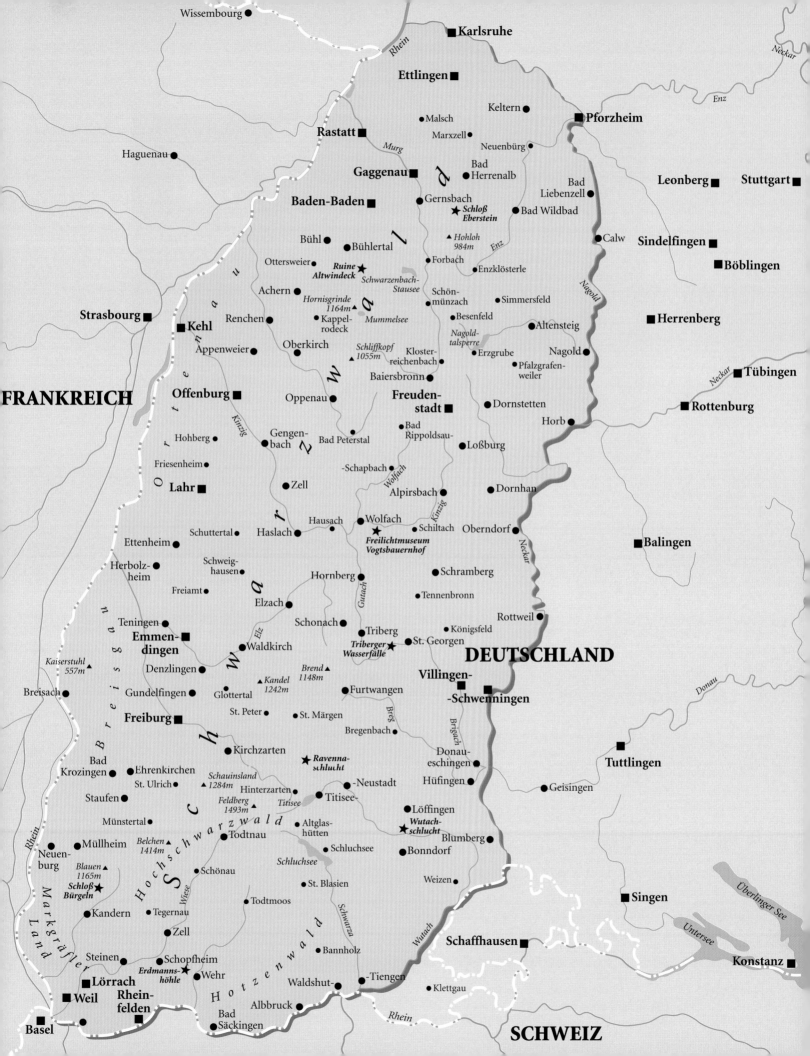

Reading Grandma's tales of the Black Forest. Many of the sagas and legends from the forest tell scary stories of witches, ghouls and ghosties and things that go bump in the night. Best to stay at home safely ensconced around the Dutch stove ...

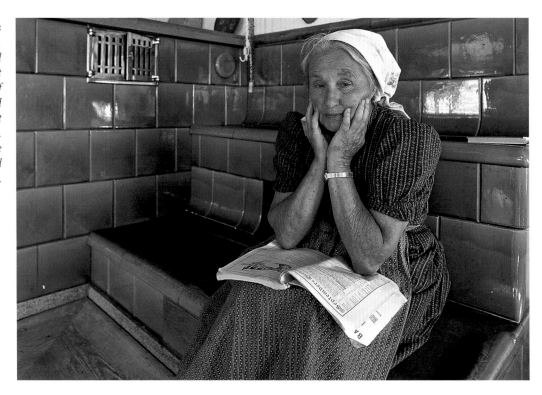

Credits

Design
hoyerdesign grafik gmbh, Freiburg

Map
Fischer Kartografie, Aichach

Translation
Ruth Chitty, Schweppenhausen

All rights reserved

Printed in Germany
Repro by Artilitho, Trento, Italy
Printed/Bound by Offizin Andersen Nexö, Leipzig
© 2006 Verlagshaus Würzburg GmbH & Co. KG
© Photos: Martin Schulte-Kellinghaus and
Erich Spiegelhalter

ISBN-13: 978-3-8003-1629-8
ISBN-10: 3-8003-1629-3

Martin Schulte-Kellinghaus and Erich Spiegelhalter live and work as freelance photographers in and near Freiburg. Operating as a team they produce slide shows on various travel topics. Both have had numerous illustrated books and reports in magazines published.

www.schulte-kellinghaus.de
www.erich-spiegelhalter.de

Annette Meisen studied communication design and has worked as a designer in Germany and abroad, winning several awards for her work. Her love of art and art history prompted her to take a second degree and begin working as a freelance travel journalist. She is the author of many publications.

Stürtz

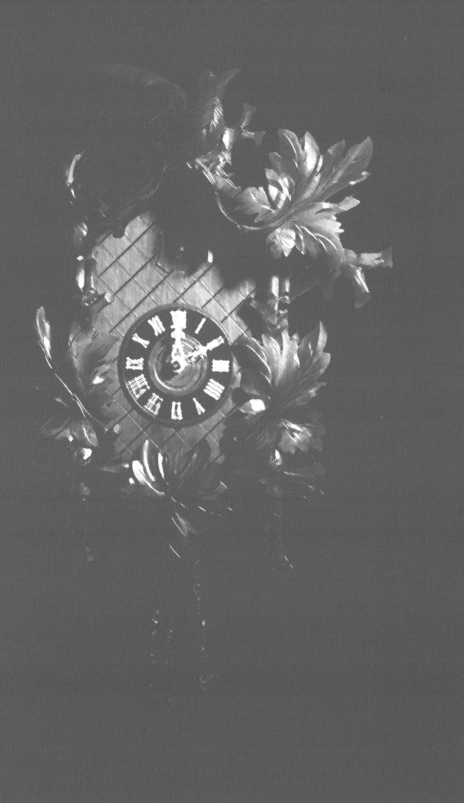